Masterpieces of

Claude Lorrain

(1911)

ISBN-13 : 978-1512345766
ISBN-10 : 1512345768
Copyright©2012-2014 Iacob Adrian
All Rights Reserved.

Notice

This documentary study use historic, archived documents. Because of this, some pages may look blurry or low quality. Still are included in this book because they have high value from critical, documentary, historical, informative and journalistic point of view .

Dtp and visual art

Iacob Adrian

THE
MASTERPIECES
OF
CLAUDE
(1600-1682)

*Sixty reproductions of photographs from the original paintings,
affording examples of the different characteristics
of the Artist's work*

Author statement

This is a series of art books.

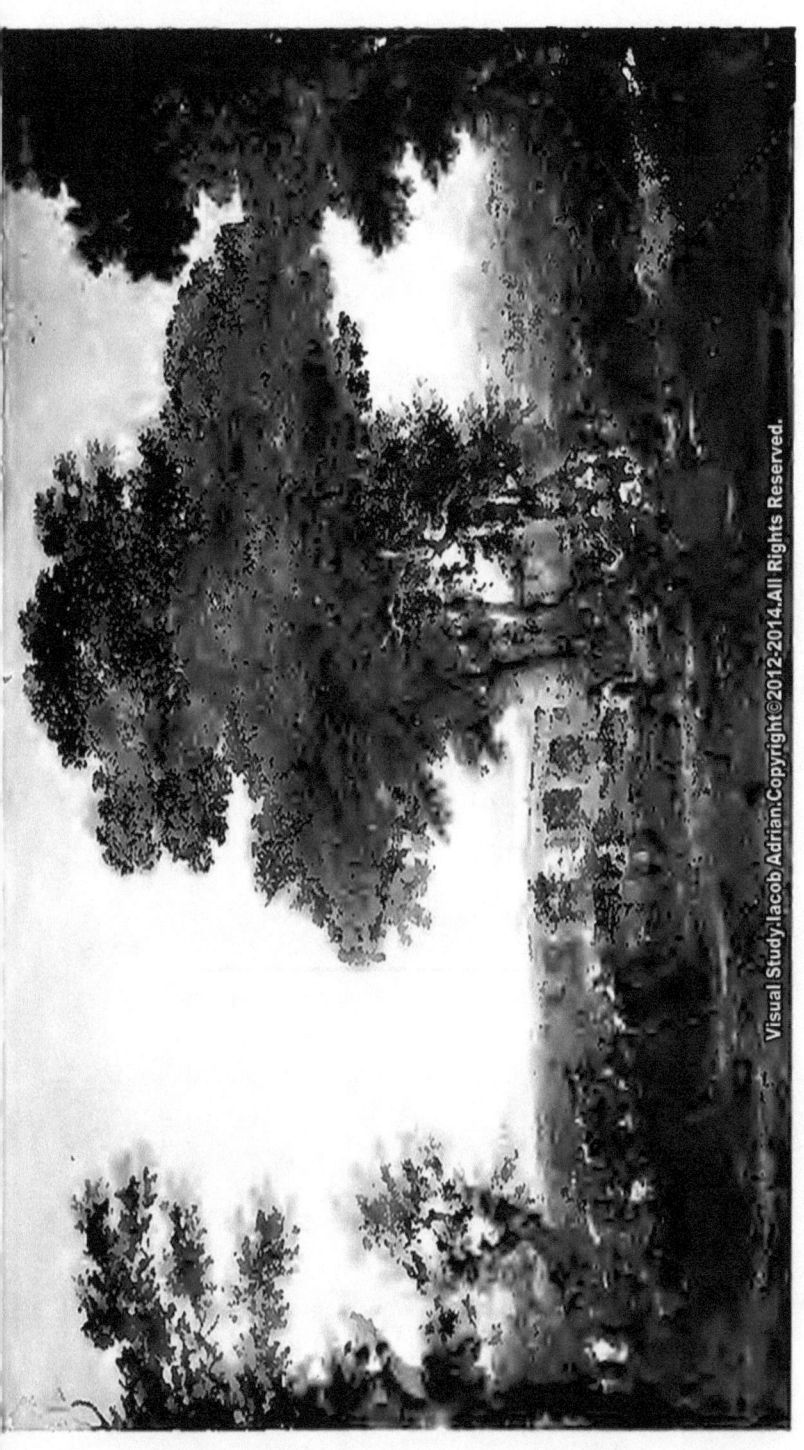

Village Fête

[L.V. 13]
Dorffest
(Louvre, Paris)
W. A. Mansell & Co., Photo.

Fête de Village

This little Book conveys the greetings of

..

to

..

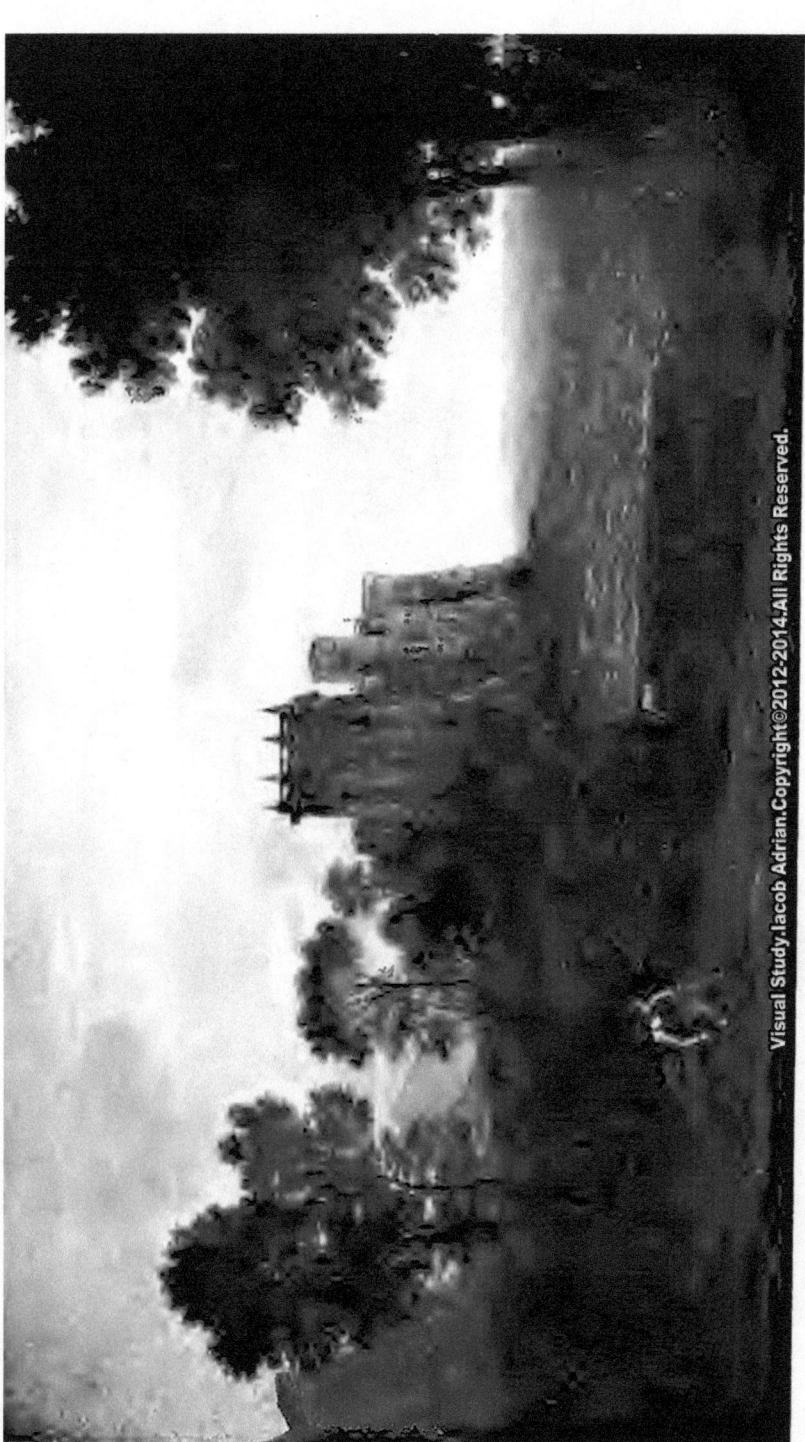

THE ENCHANTED CASTLE

[L.V. 162]
DAS VERZAUBERTE SCHLOSS
(*Lady Wantage, London*)
Braun, Clément & Cie, Photo.

LE CHATEAU ENCHANTÉ

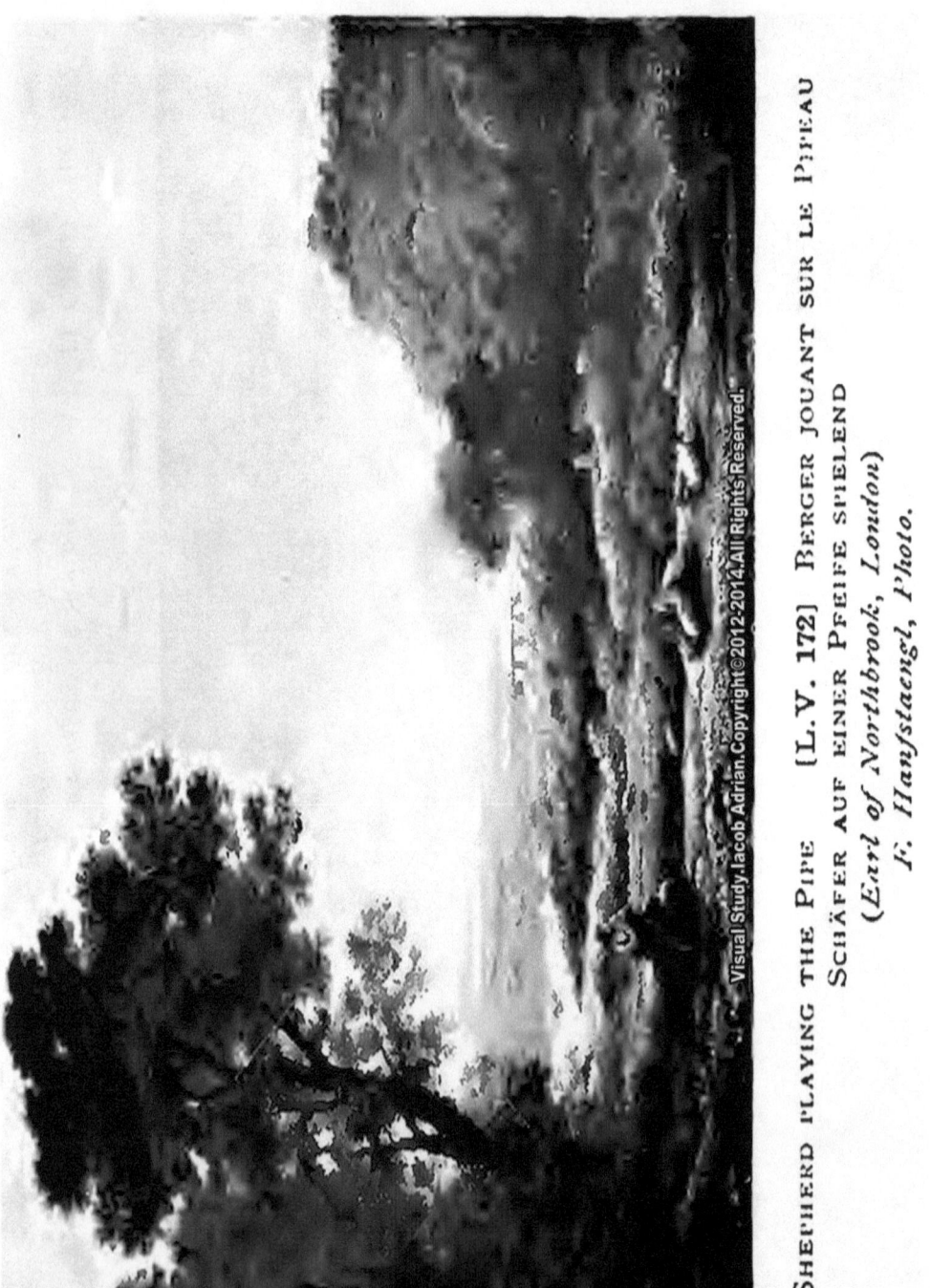

Shepherd playing the Pipe [L.V. 172] Berger jouant sur le Pipeau
Schäfer auf einer Pfeife spielend
(*Earl of Northbrook, London*)
F. Hanfstaengl, Photo.

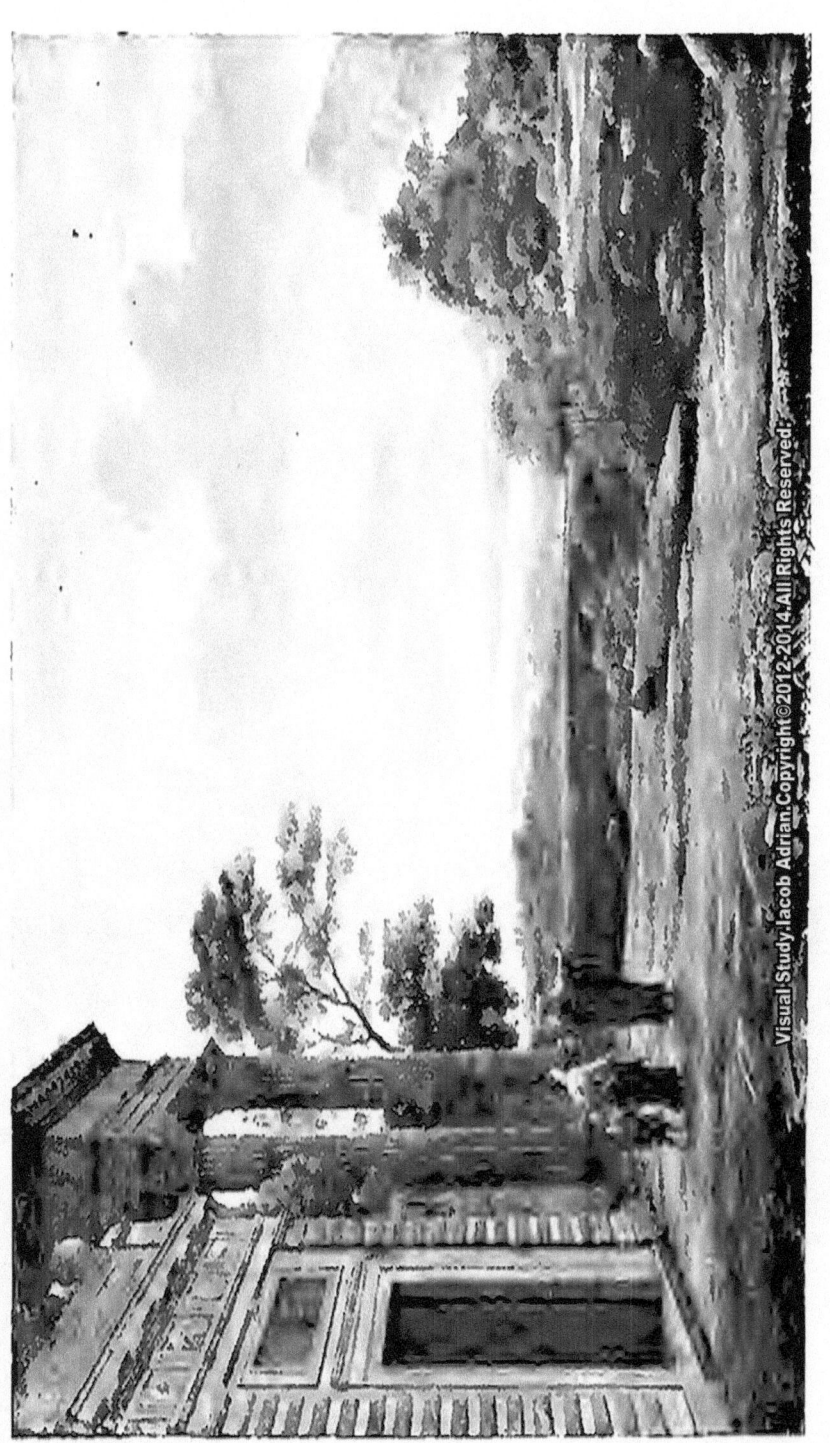

Abraham sends away Hagar [L.V. 173] Abraham renvoie Agar
(Pinacotheca, Munich) (Pinacothique, Munich)
Abraham verstösst Hagar
(München, Pinakothek) F. Hanfstaengl, Photo.

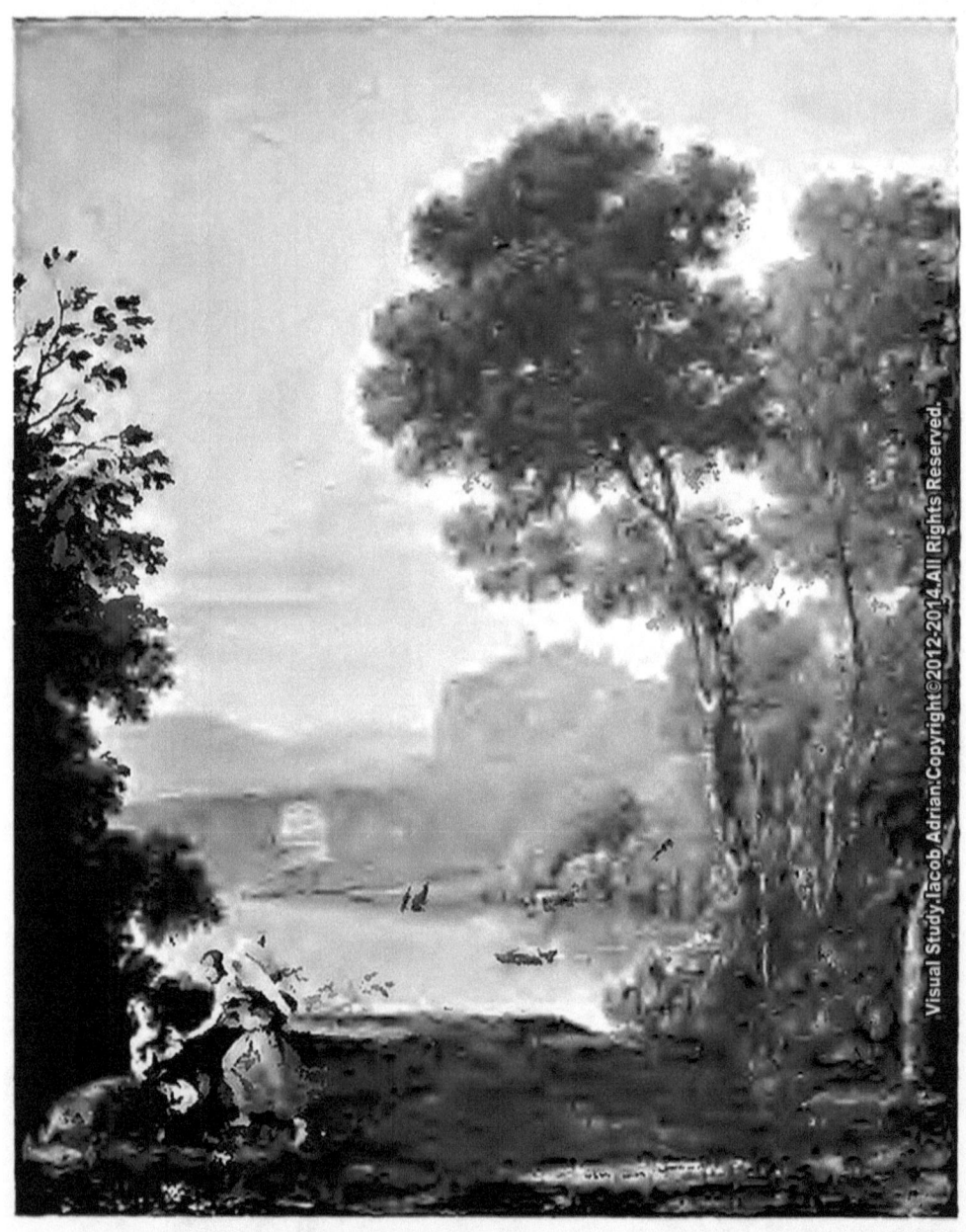

Hagar and the Angel. [L.V. 106] Agar et l'Ange
Hagar und der Engel
(*National Gallery, London*)
F. Hanfstaengl, Photo.

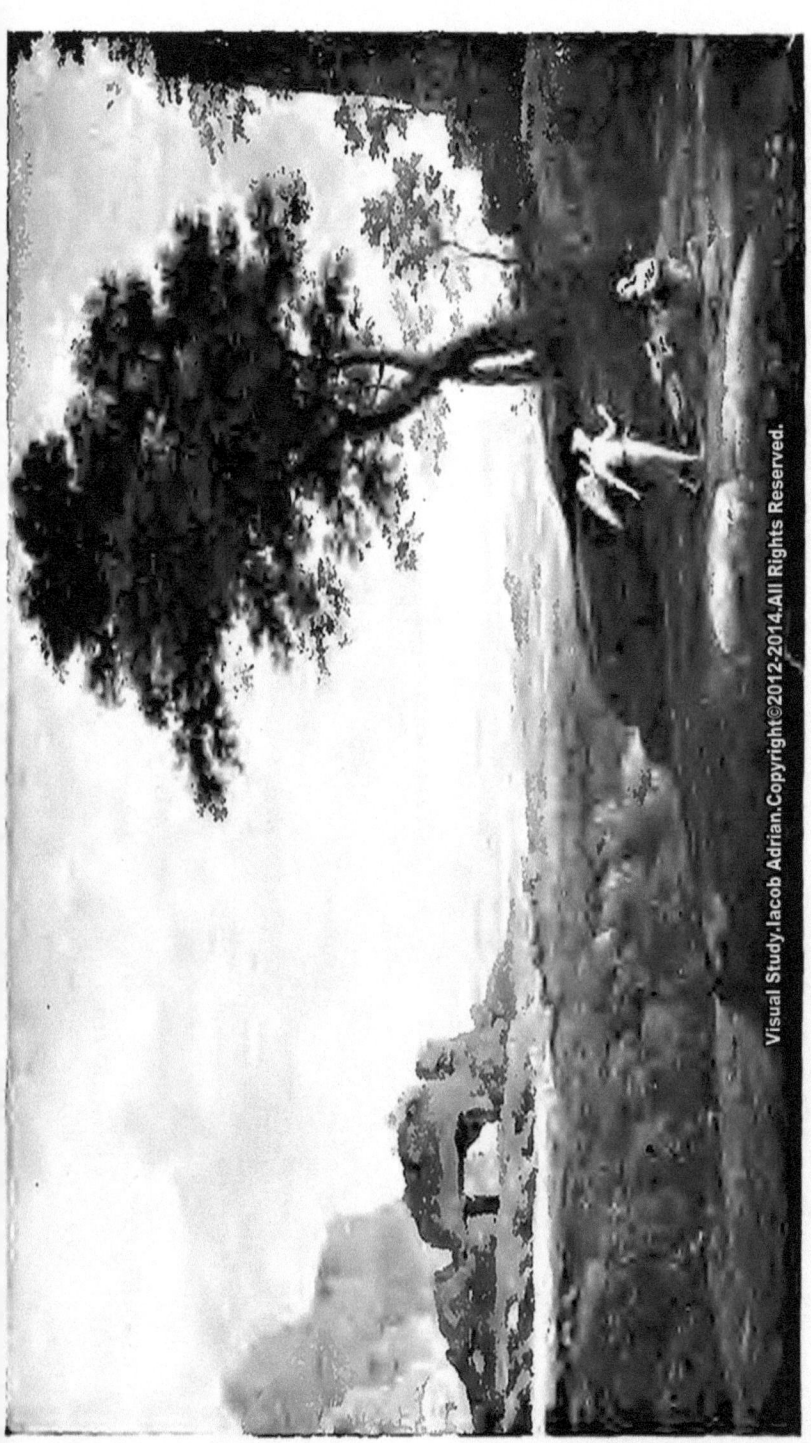

[L.V. 174]

HAGAR AND THE ANGEL HAGAR UND DER ENGEL AGAR ET L'ANGE
(Pinacotheca, Munich) *(München, Pinakothek)* *(Pinacothèque, Munich)*
F. Hanfstaengl, Photo.

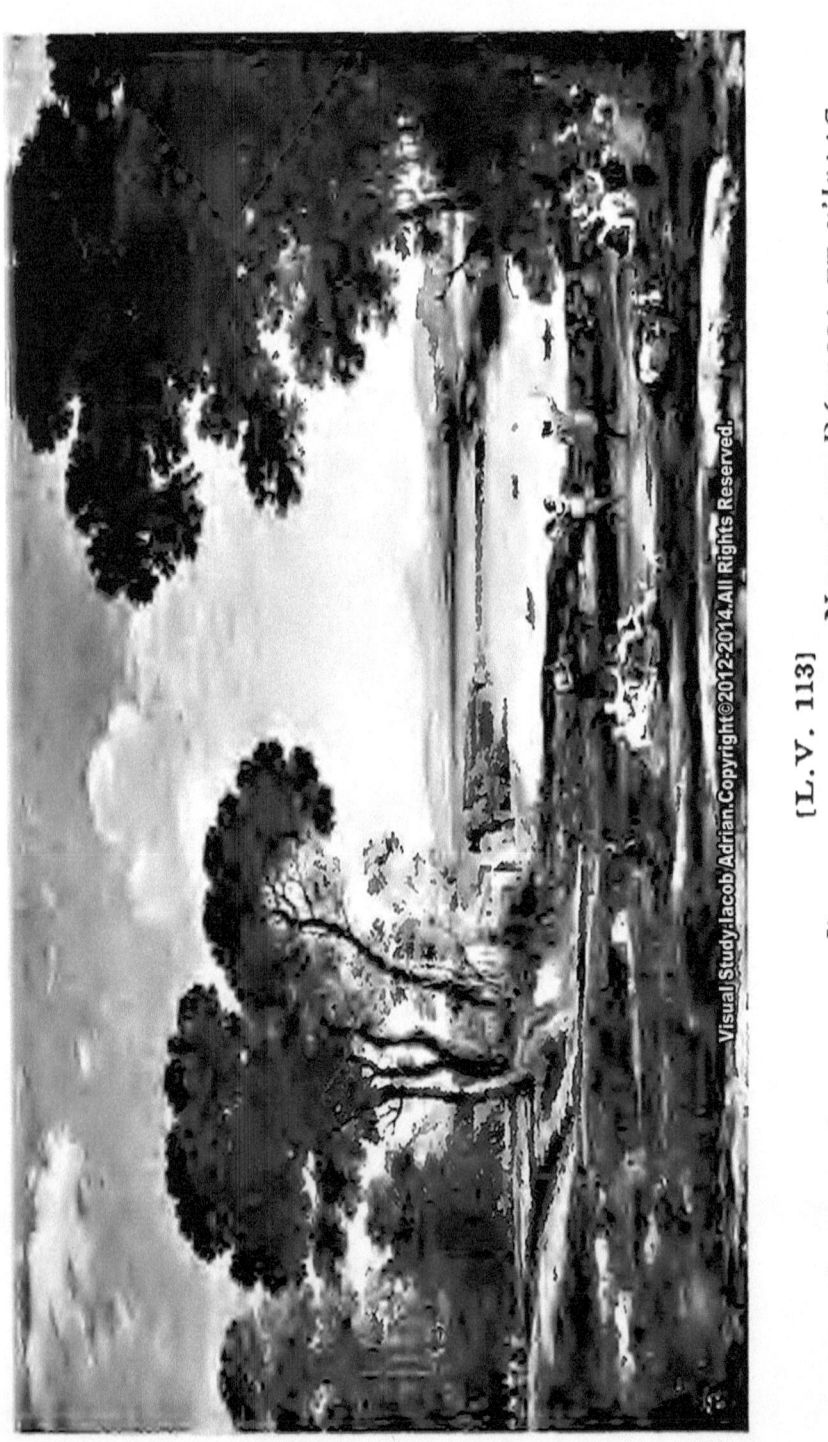

[L.V. 113]

Marriage of Isaac and Rebecca
(The Mill)
(Doria Gallery, Rome)

Noces de Rébecca et d'Isaac
(Le Moulin)
(Galerie Doria, Rome)

Hochzeit Isaaks mit Rebekka (Die Mühle)
(Rom, Galerie Doria)

D. Anderson, Photo.

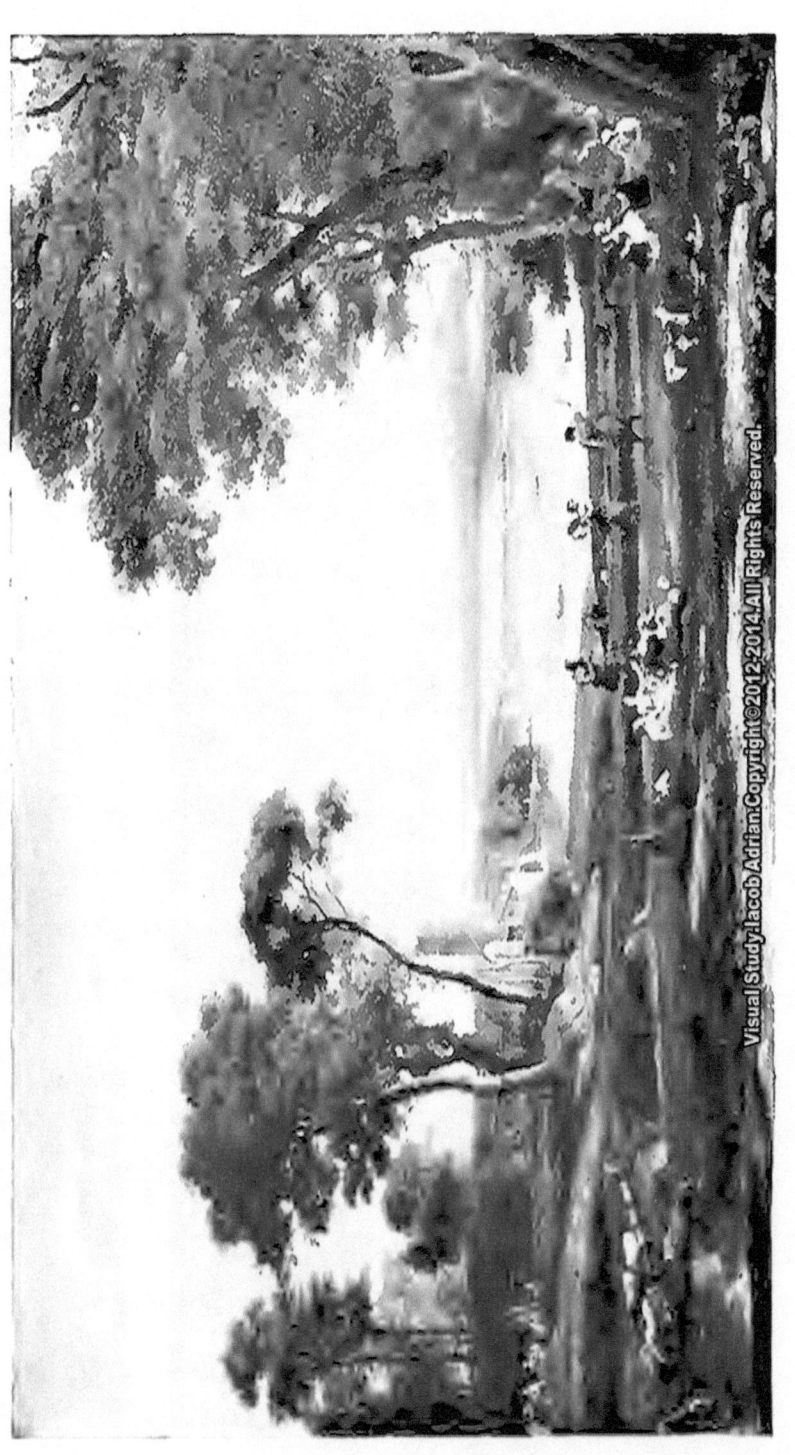

[L.V. 113]

MARRIAGE OF ISAAC AND REBECCA
(THE MILL)
HOCHZEIT ISAAKS MIT REBEKKA (DIE MÜHLE)
NOCES DE RÉBECCA ET D'ISAAC
(LE MOULIN)
(National Gallery, London) F. Hanfstaengl, Photo.

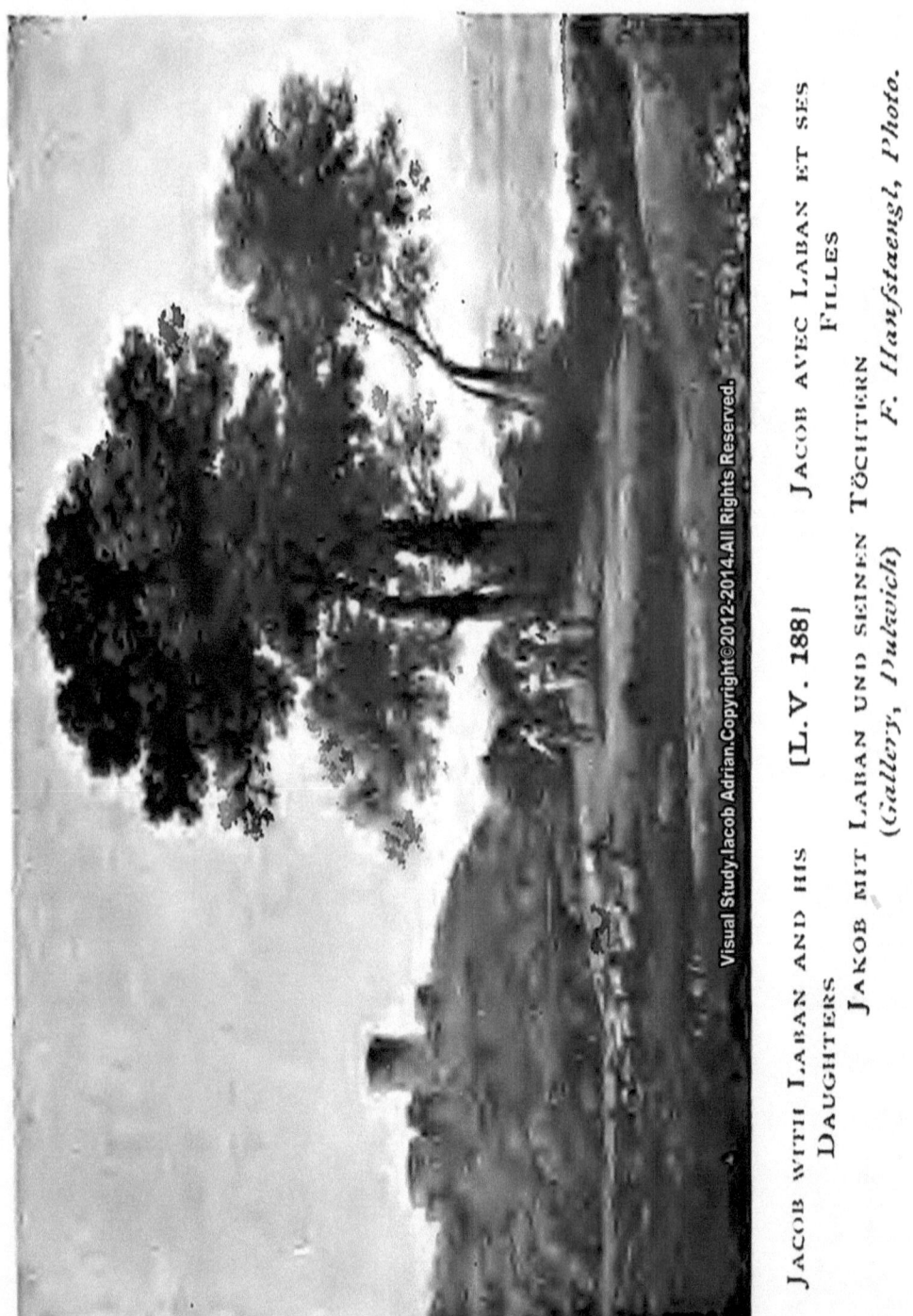

Jacob with Laban and his Daughters [L.V. 188] Jacob avec Laban et ses Filles
Jakob mit Laban und seinen Töchtern
(Gallery, Dulwich) F. Hanfstaengl, Photo.

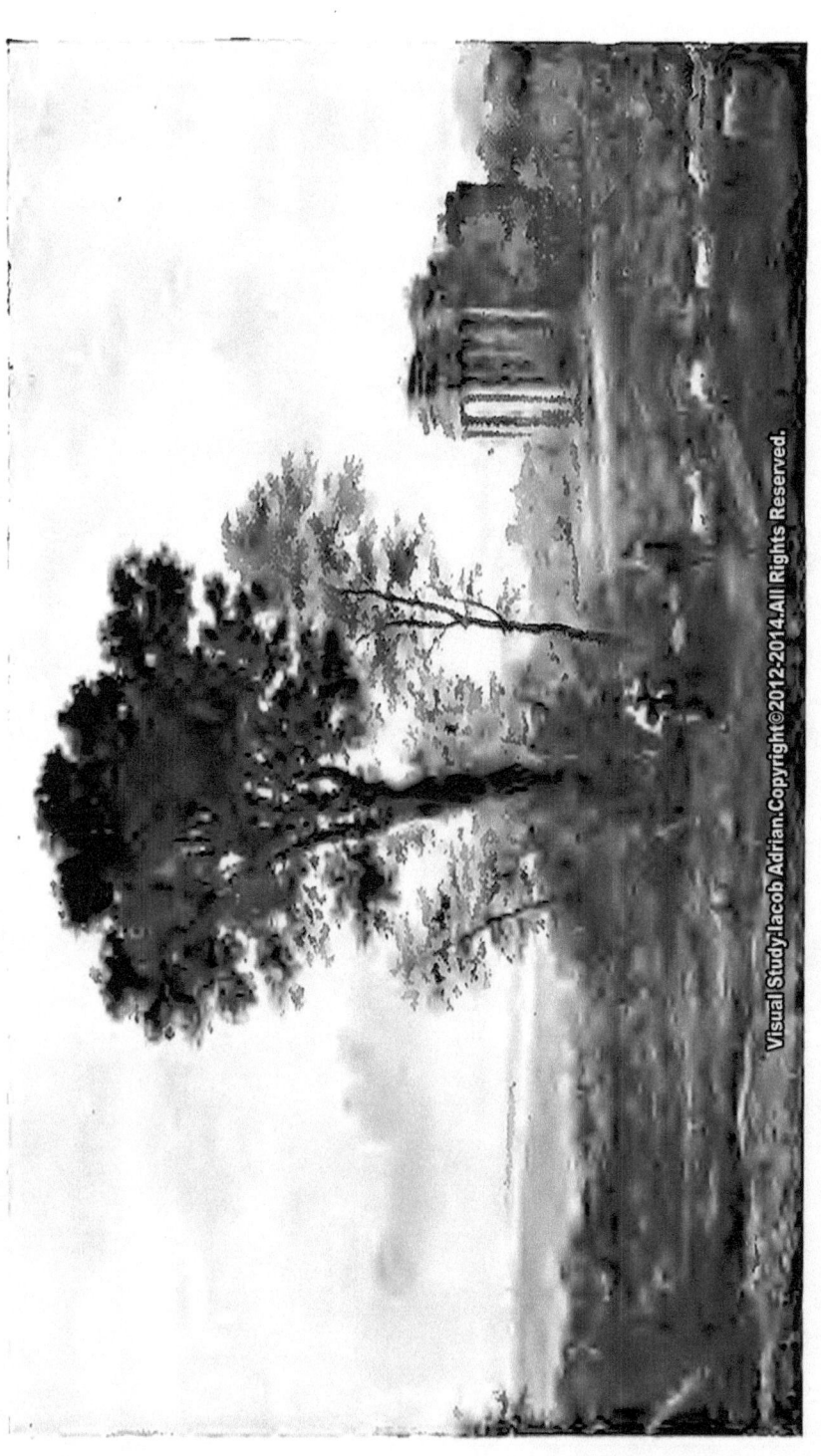

JACOB, LEAH AND RACHEL. [L.V. 169] JACOB, LIA ET RACHEL.
(*The Hermitage, St. Petersburg*) (*L'Ermitage, Saint-Pétersbourg*)
JAKOB, LEA UND RAHEL
(*St. Petersburg, Eremitage*) F. Hanfstængl, Photo.

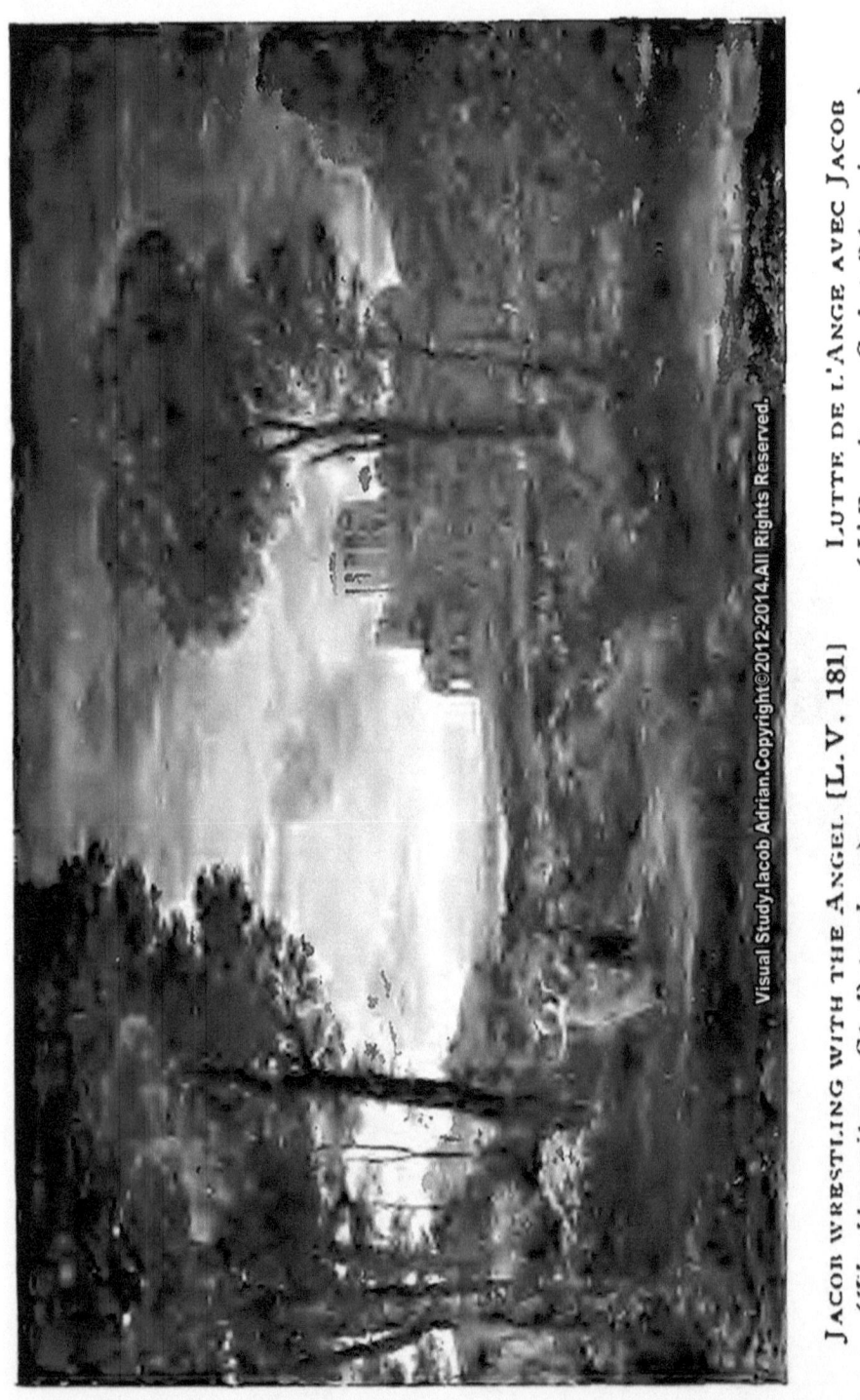

JACOB WRESTLING WITH THE ANGEL. [L.V. 181] LUTTE DE L'ANGE AVEC JACOB
(*The Hermitage, St. Petersburg*) (*L'Ermitage, Saint-Pétersbourg*)
JAKOB RINGT MIT DEM ENGEL
(*St. Petersburg, Eremitage*) F. Hanfstaengl, Photo.

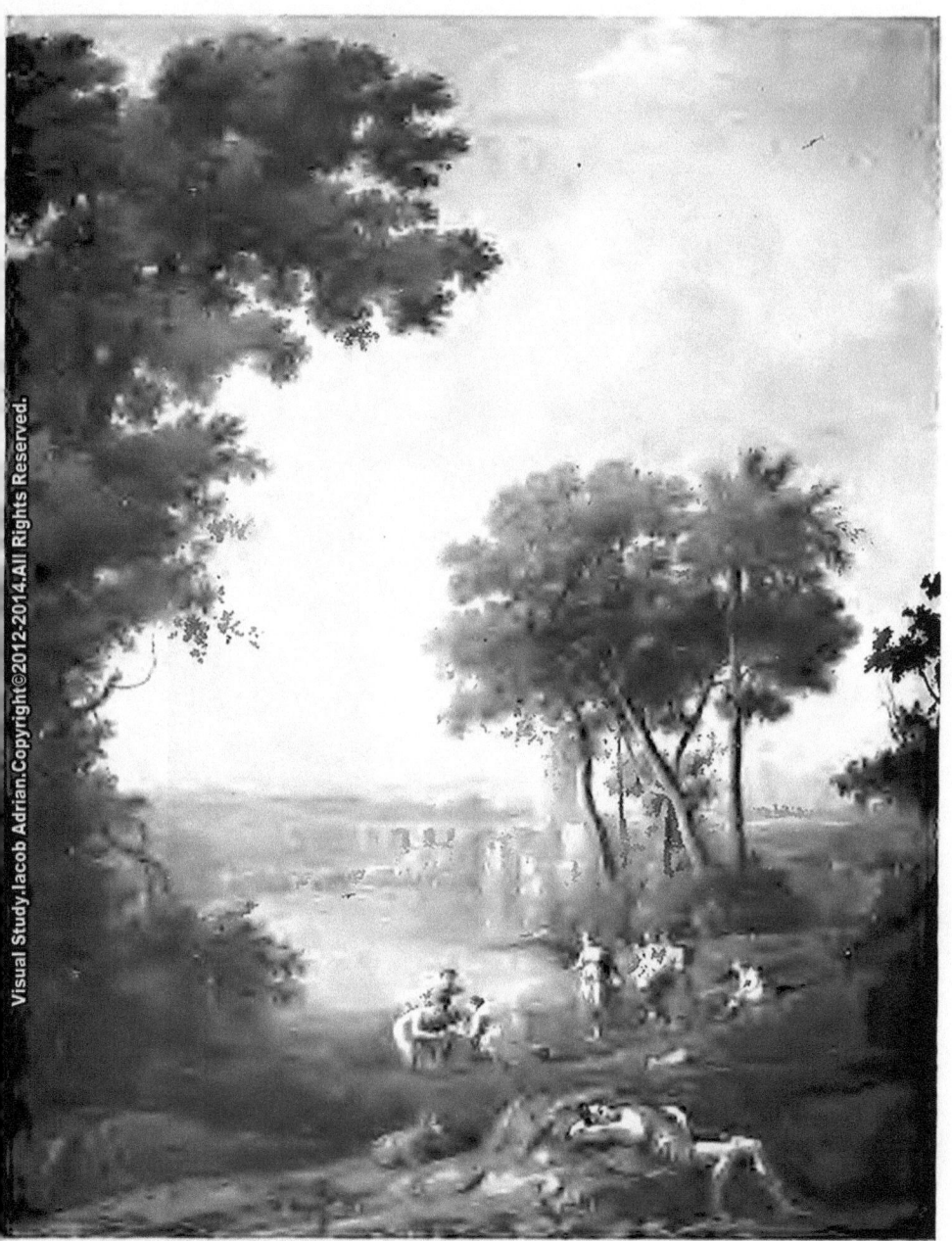

The Finding of Moses [L.V. 47] Moïse sauvé des Eaux
Die Auffindung Mosis
(Prado, Madrid)
F. Hanfstaengl, Photo.

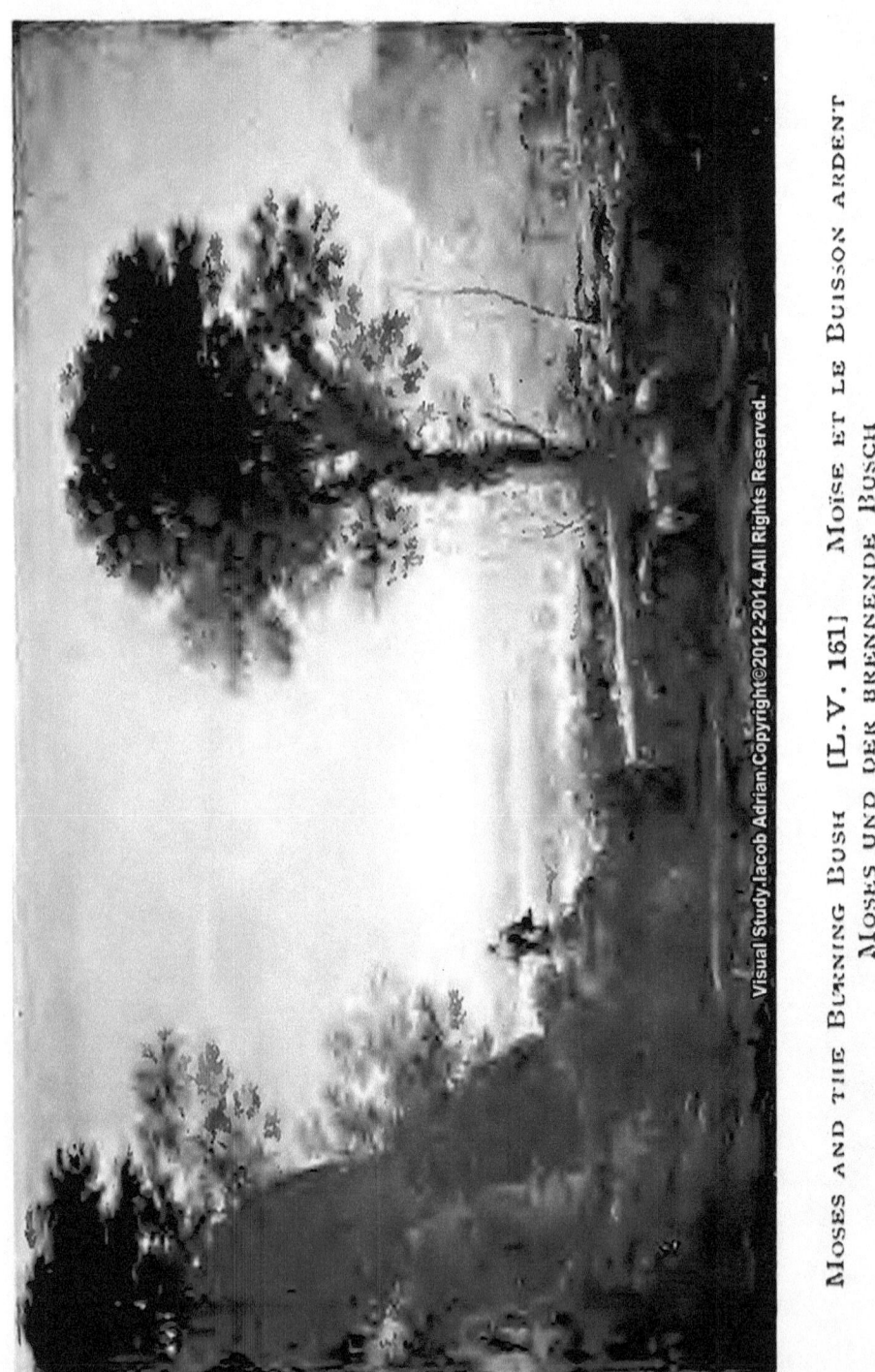

MOSES AND THE BURNING BUSH [L.V. 161]　MOÏSE ET LE BUISSON ARDENT
MOSES UND DER BRENNENDE BUSCH
(Earl of Ellesmere, London)
Walter L. Bourke, Photo.

THE WORSHIP OF THE GOLDEN CALF [L.V. 129] L'ADORATION DU VEAU D'OR
DIE ANBETUNG DES GOLDENEN KALBES
(*Duke of Westminster, London*)
Braun Clément & Cie. Photo.

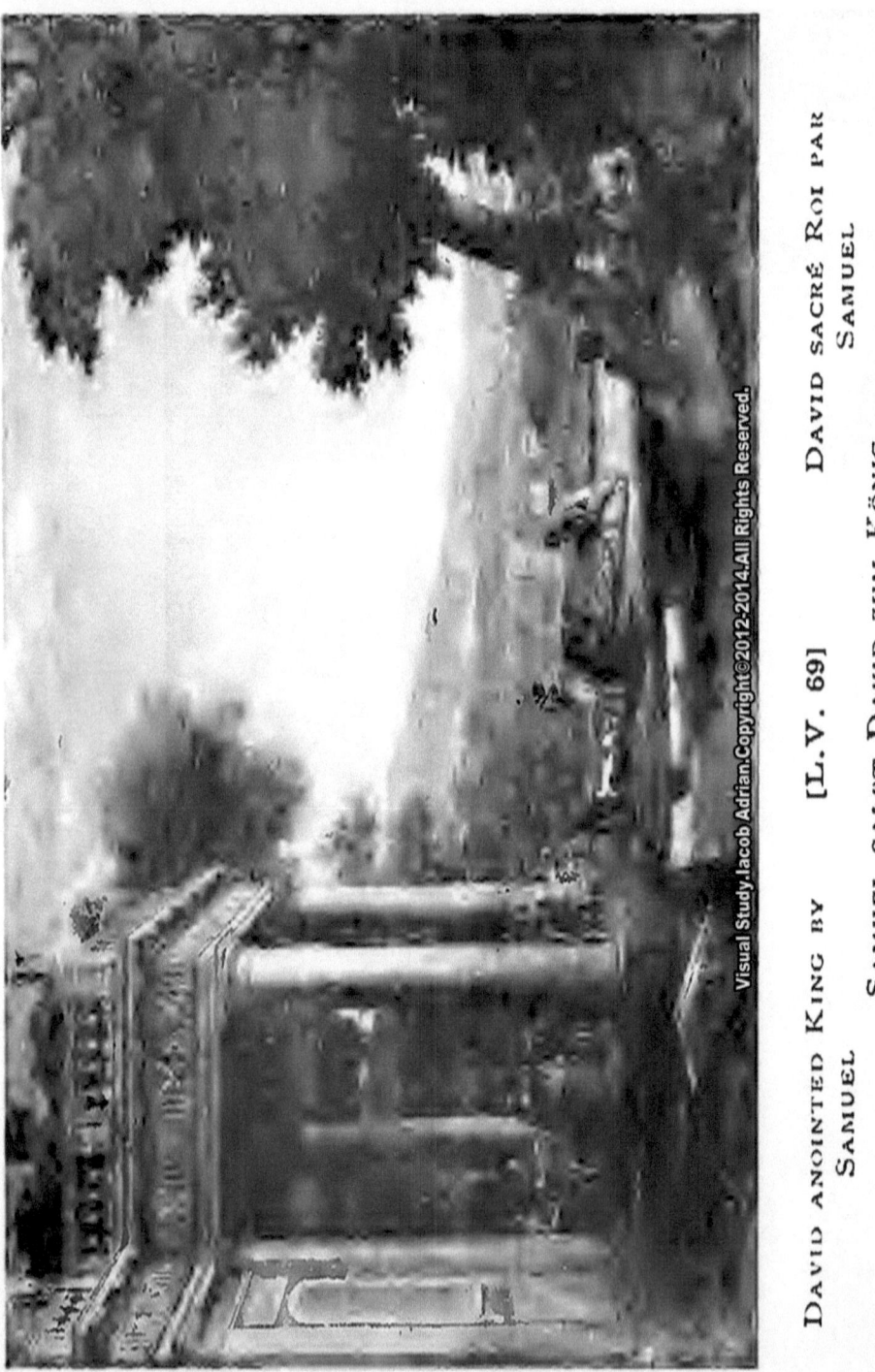

David anointed King by Samuel [L.V. 69] David sacré Roi par Samuel

Samuel salbt David zum König (Louvre, Paris) W. A. Mansell & Co., Photo.

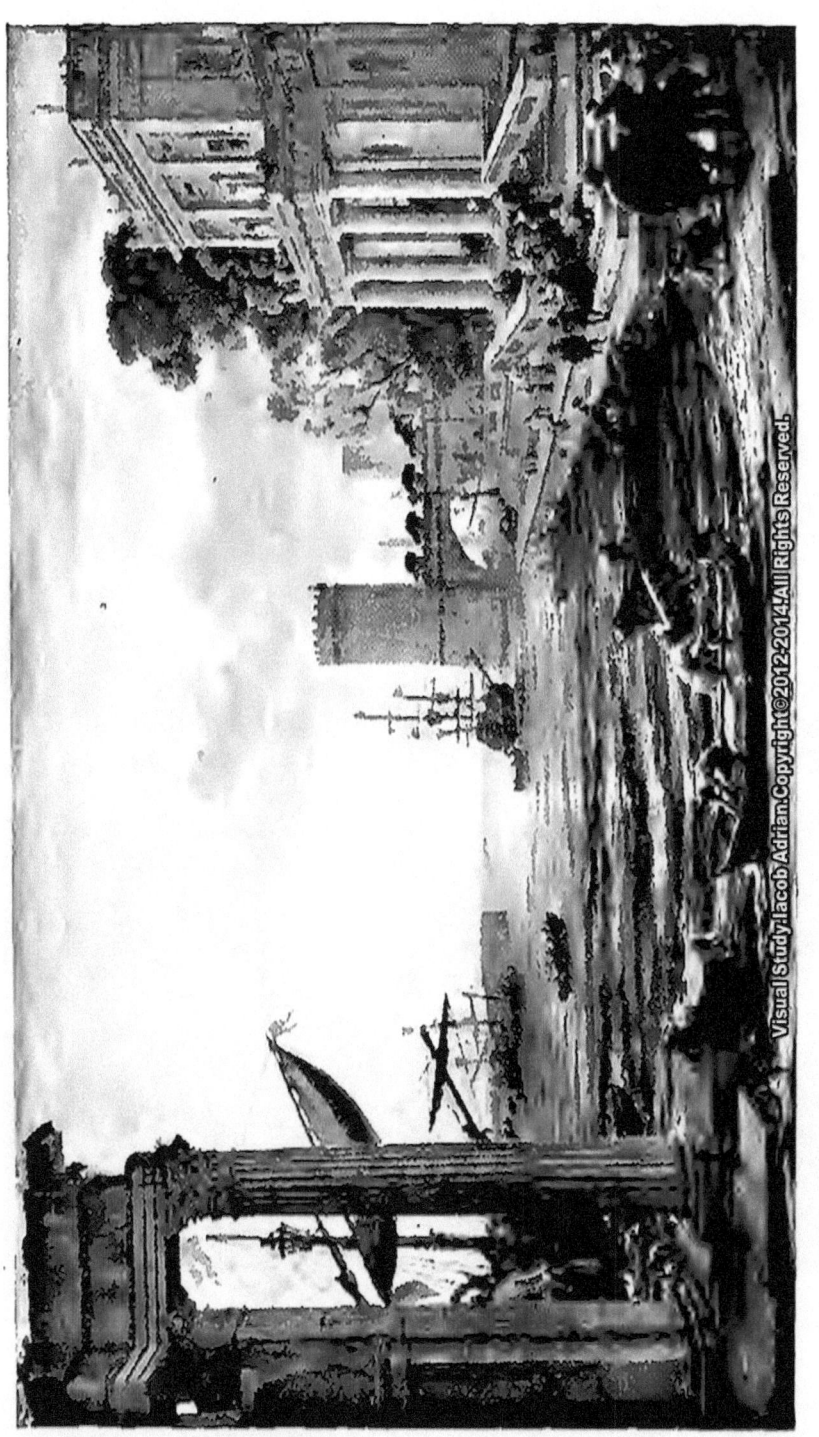

Embarkation of the Queen of Sheba [L.V. 114] Embarquement de la Reine de Saba
Einschiffung der Königin von Saba
(National Gallery, London) F. Hanfstaengl, Photo.

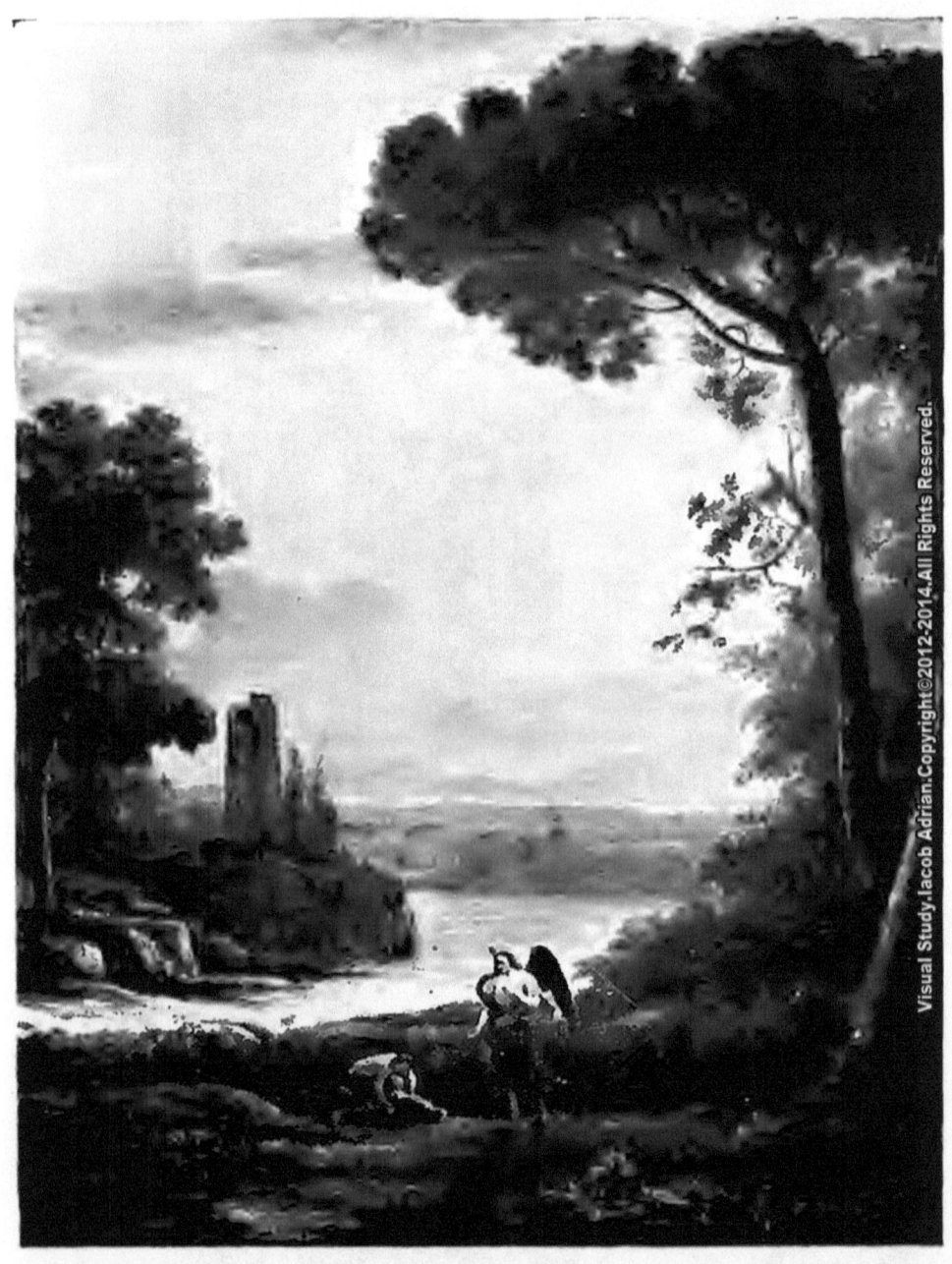

Tobias and the Angel [L.V. 50]　　Tobie et l'Ange
Tobias und der Engel
(Prado, Madrid)
F. Hanfstaengl, Photo.

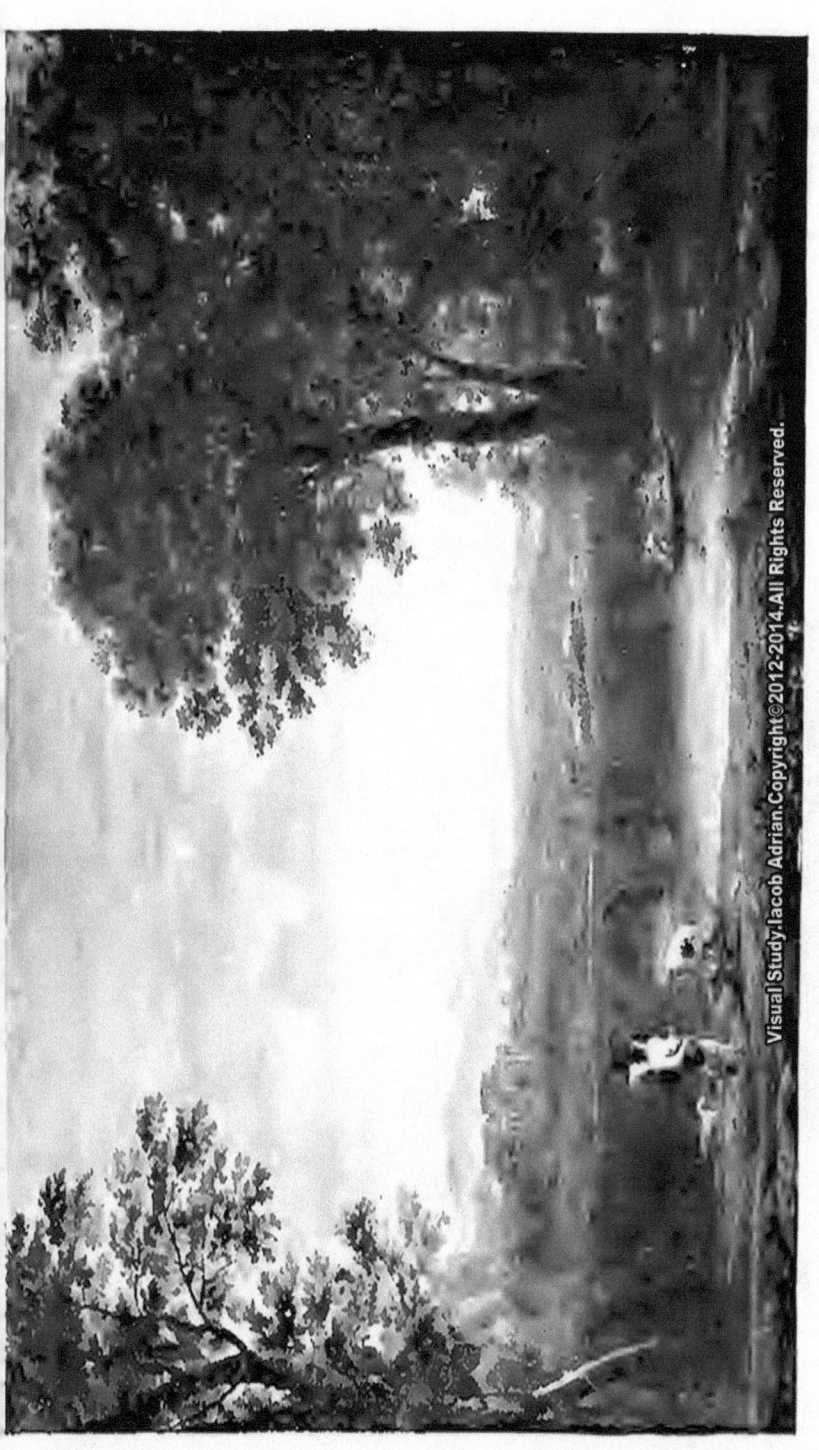

TOBIAS AND THE ANGEL [L.V. 160] TOBIE ET L'ANGE
(*The Hermitage, St. Petersburg*) (*L'Ermitage, Saint-Pétersbourg*)
TOBIAS UND DER ENGEL
(*St. Petersburg, Eremitage*) *F. Hanfstaengl, Photo.*

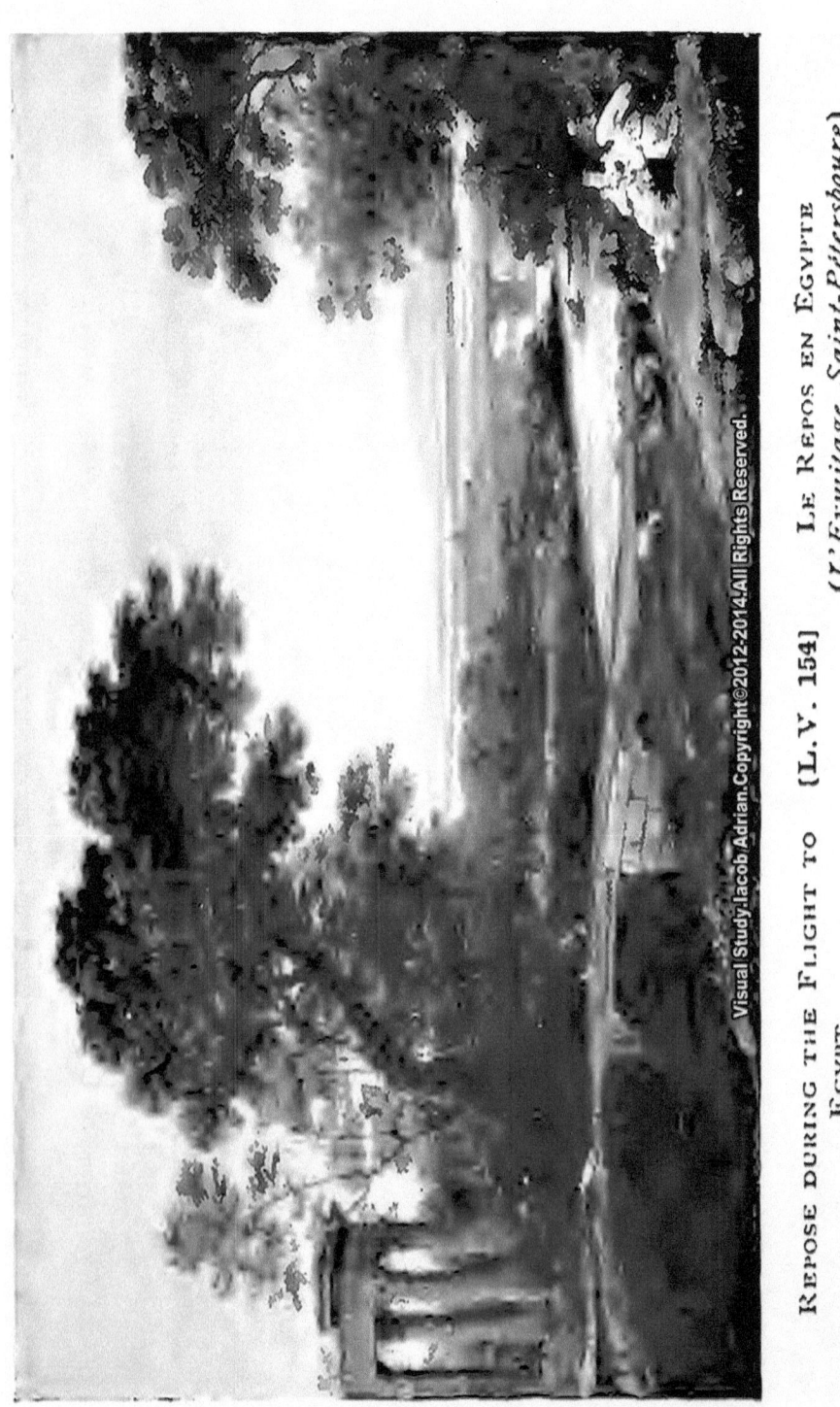

Repose during the Flight to Egypt [L.V. 154] Le Repos en Égypte
(The Hermitage, St. Petersburg) (L'Ermitage, Saint-Pétersbourg)
Ruhe auf der Flucht nach Ägypten F. Hanfstaengl, Photo.
(St. Petersburg, Eremitage)

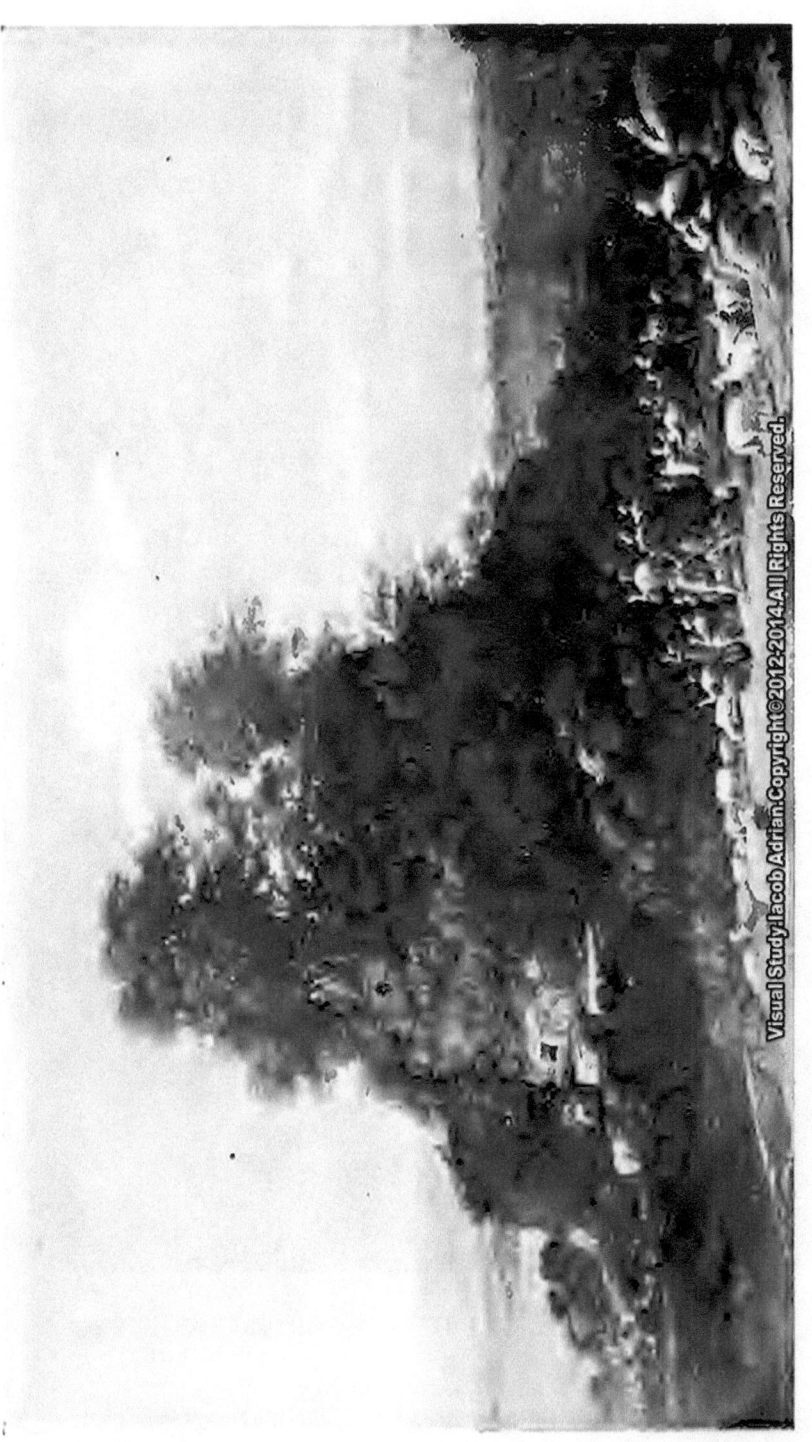

The Sermon on the Mount [L.V. 138] Le Sermon sur la Montagne
Die Bergpredigt
(Duke of Westminster, London)
Braun, Clément & Cie, Photo.

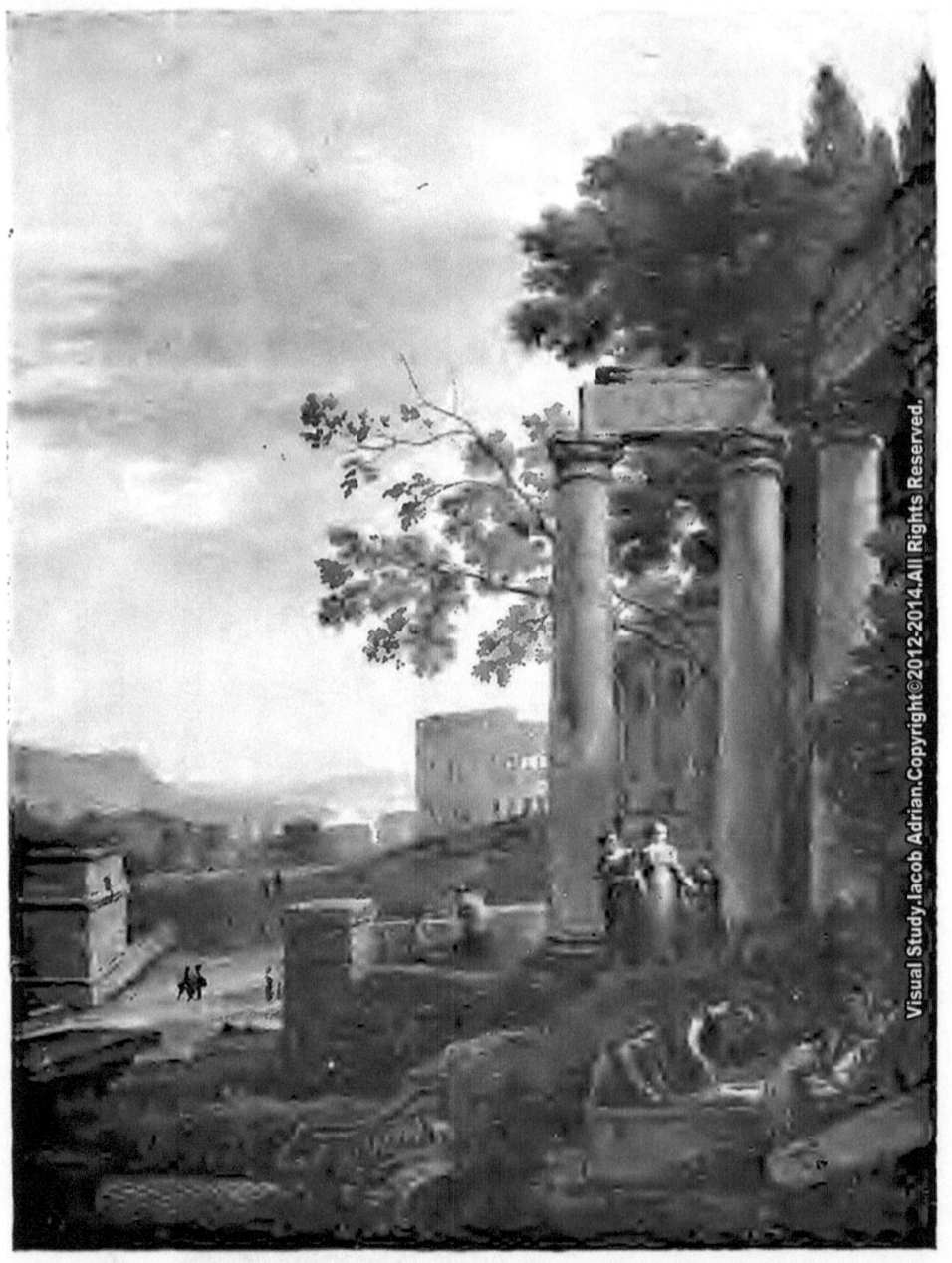

BURIAL OF ST. SABINA [L.V. 48] ENTERREMENT DE STE SABINE

BEGRÄBNIS DER HL. SABINA
(*Prado, Madrid*) *F. Hanfstaengl, Photo.*

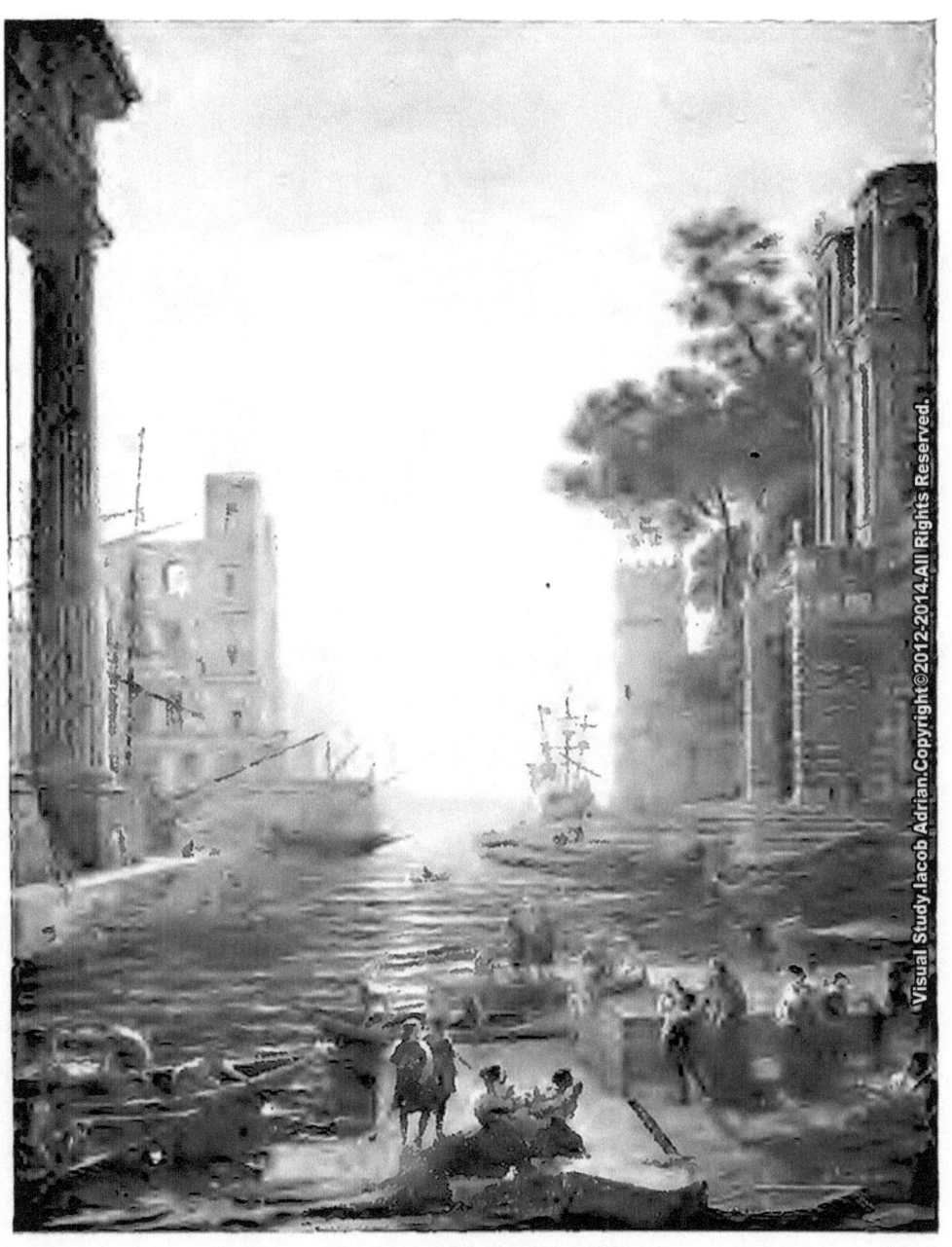

ST. PAULA LEAVING OSTIA [L.V. 49] STE PAULE PARTANT D'OSTIE
ST. PAULA VERLÄSST OSTIA
(*Prado, Madrid*)
F. Hanfstaengl, Photo.

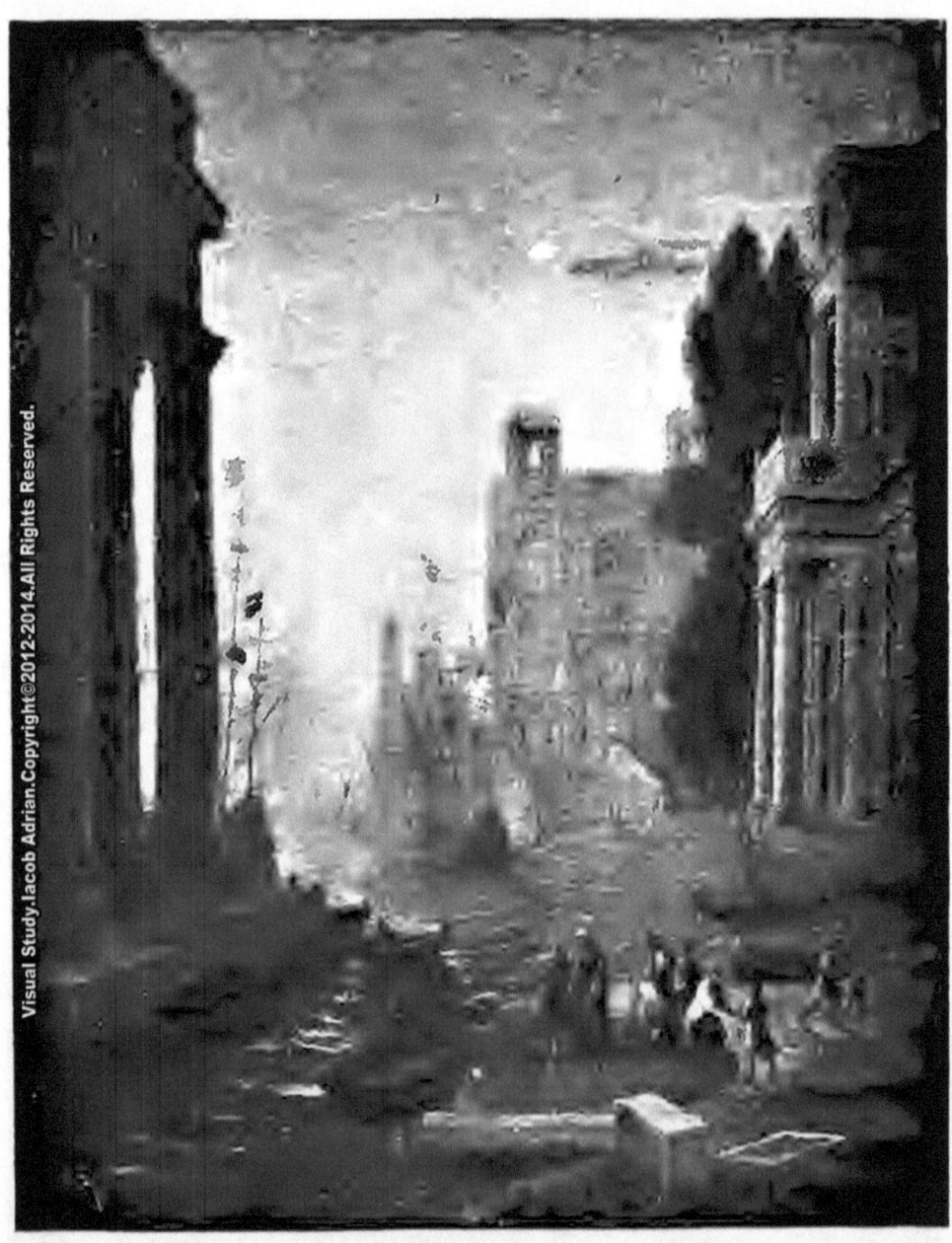

ST. PAULA LEAVING OSTIA [L.V. 49] STE PAULE PARTANT D'OSTIE
ST. PAULA VERLÄSST OSTIA
(Gallery, Dulwich)
F. Hanfstaengl, Photo.

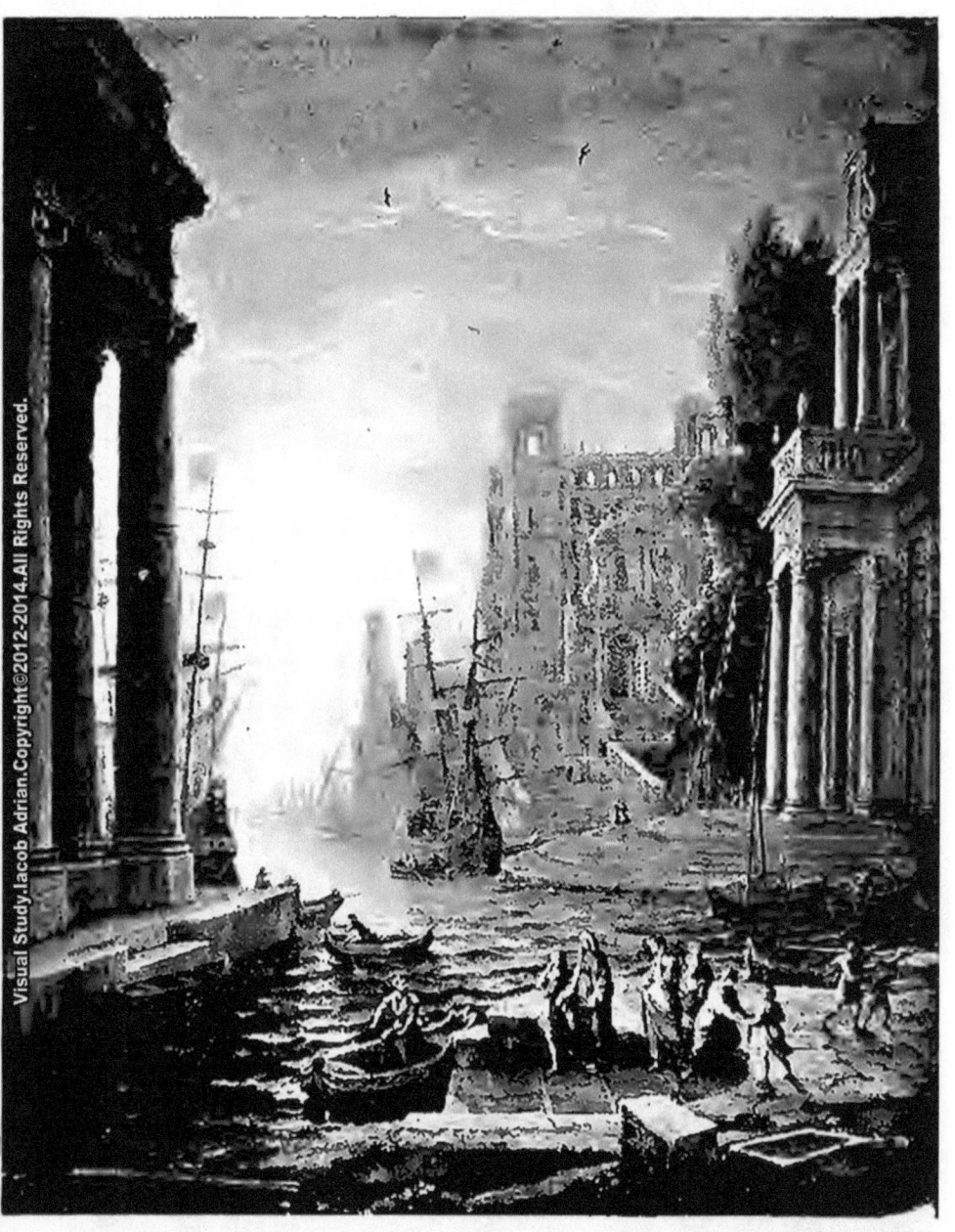

St. Paula leaving Ostia　　[L.V. 49]　Ste Paule partant d'Ostie
St. Paula verlässt Ostia
(*Duke of Wellington, London*)
Walter L. Bourke, Photo.

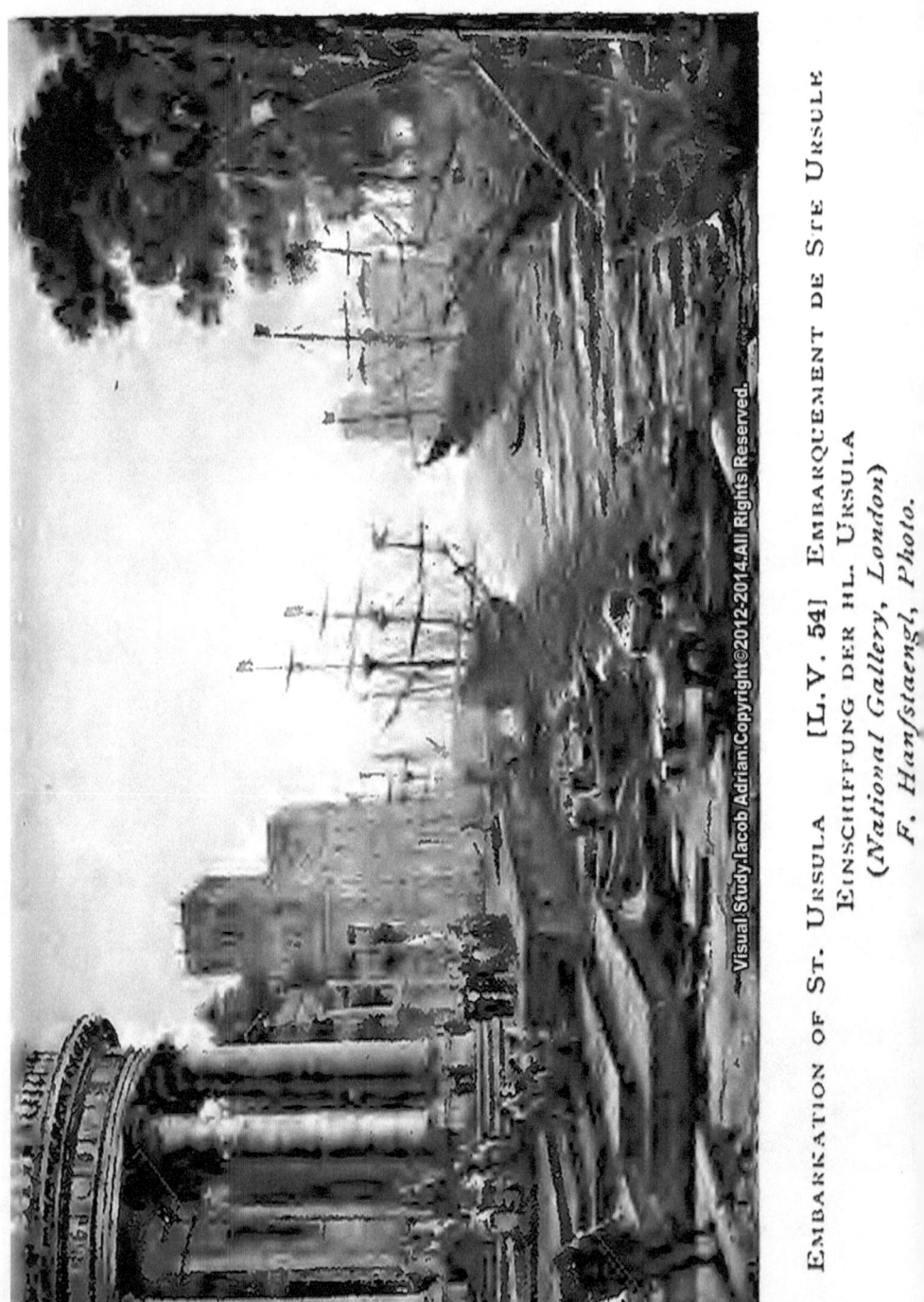

EMBARKATION OF ST. URSULA [L.V. 54] EMBARQUEMENT DE STE URSULE
EINSCHIFFUNG DER HL. URSULA
(*National Gallery, London*)
F. Hanfstaengl, Photo.

DEMOSTHENES ON THE SEA-SHORE [L.V. 171] DÉMOSTHÈNE SUR LE BORD DE LA MER

DEMOSTHENES AM GESTADE
(Earl of Ellesmere, London) Walter L. Bourke, Photo.

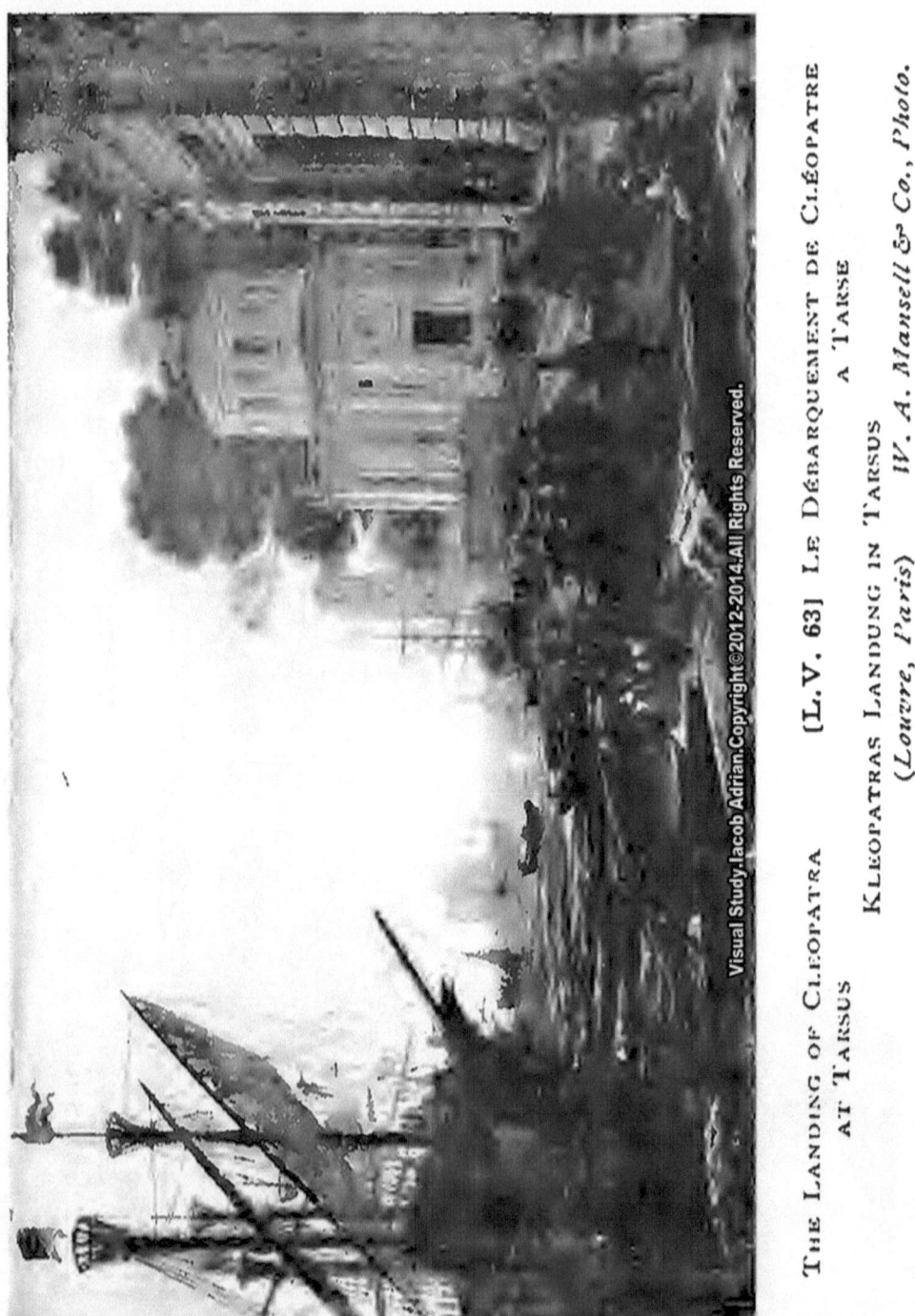

The Landing of Cleopatra at Tarsus [L.V. 63] Le Débarquement de Cléopâtre a Tarse

Kleopatras Landung in Tarsus *W. A. Mansell & Co., Photo.*
(Louvre, Paris)

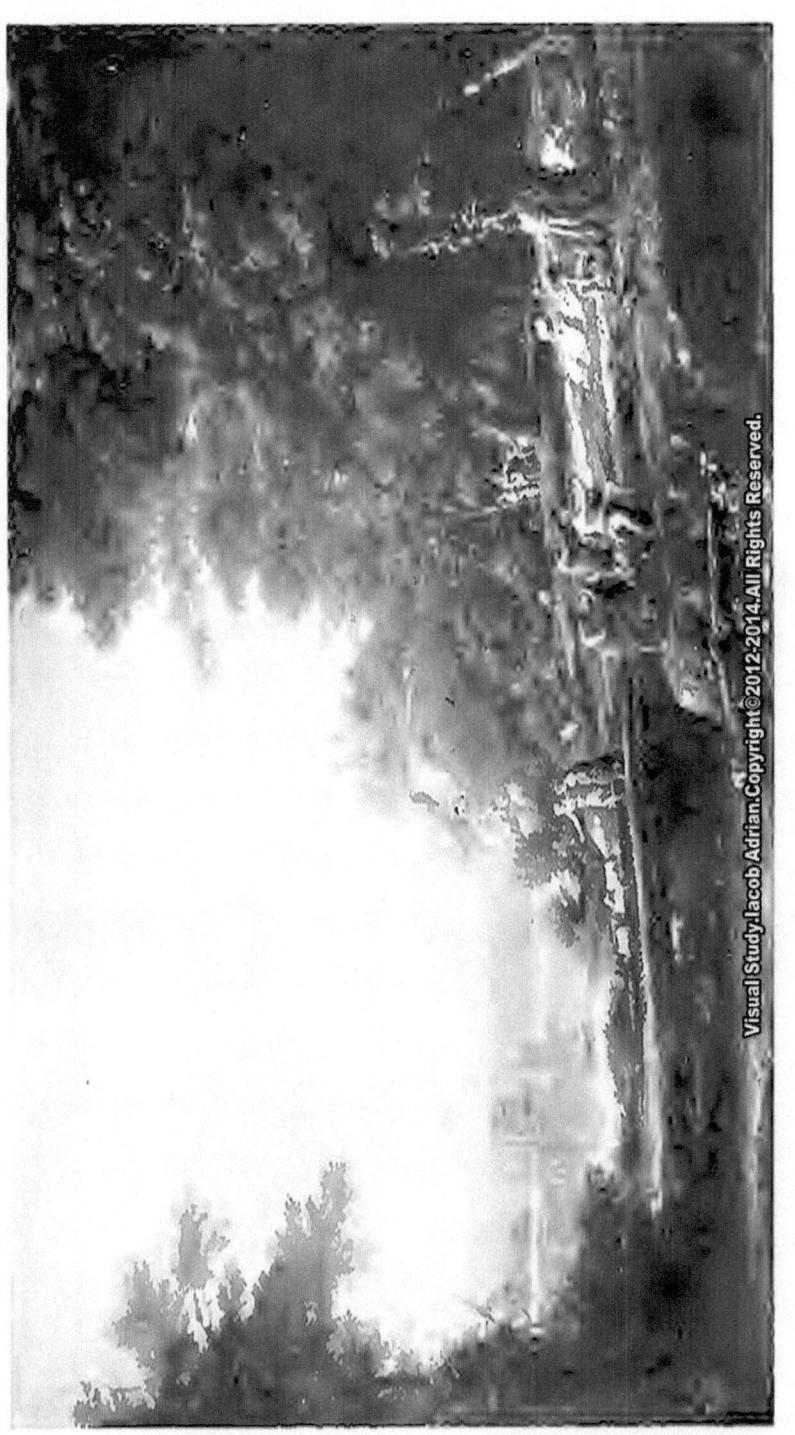

APOLLO AND MARSYAS [L.V. 45] APOLLON ET MARSYAS
(The Hermitage, St. Petersburg) (L'Ermitage, Saint-Pétersbourg)
APOLL UND MARSYAS
(St. Petersburg, Eremitage)
Braun, Clément & Cie, Photo.

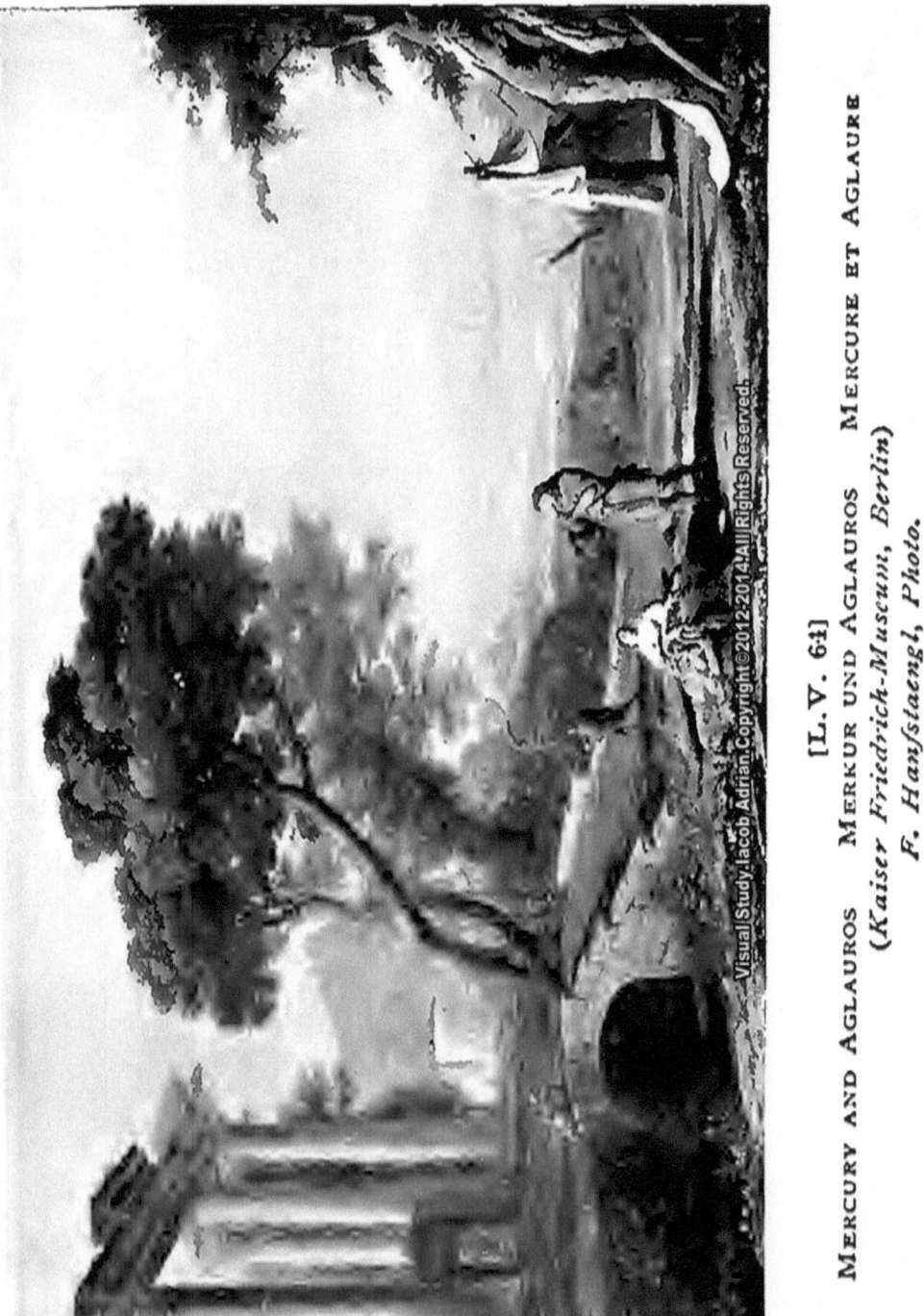

MERCURY AND AGLAUROS MERKUR UND AGLAUROS MERCURE ET AGLAURE
(*Kaiser Friedrich-Museum, Berlin*)
F. *Hanfstaengl, Photo.*

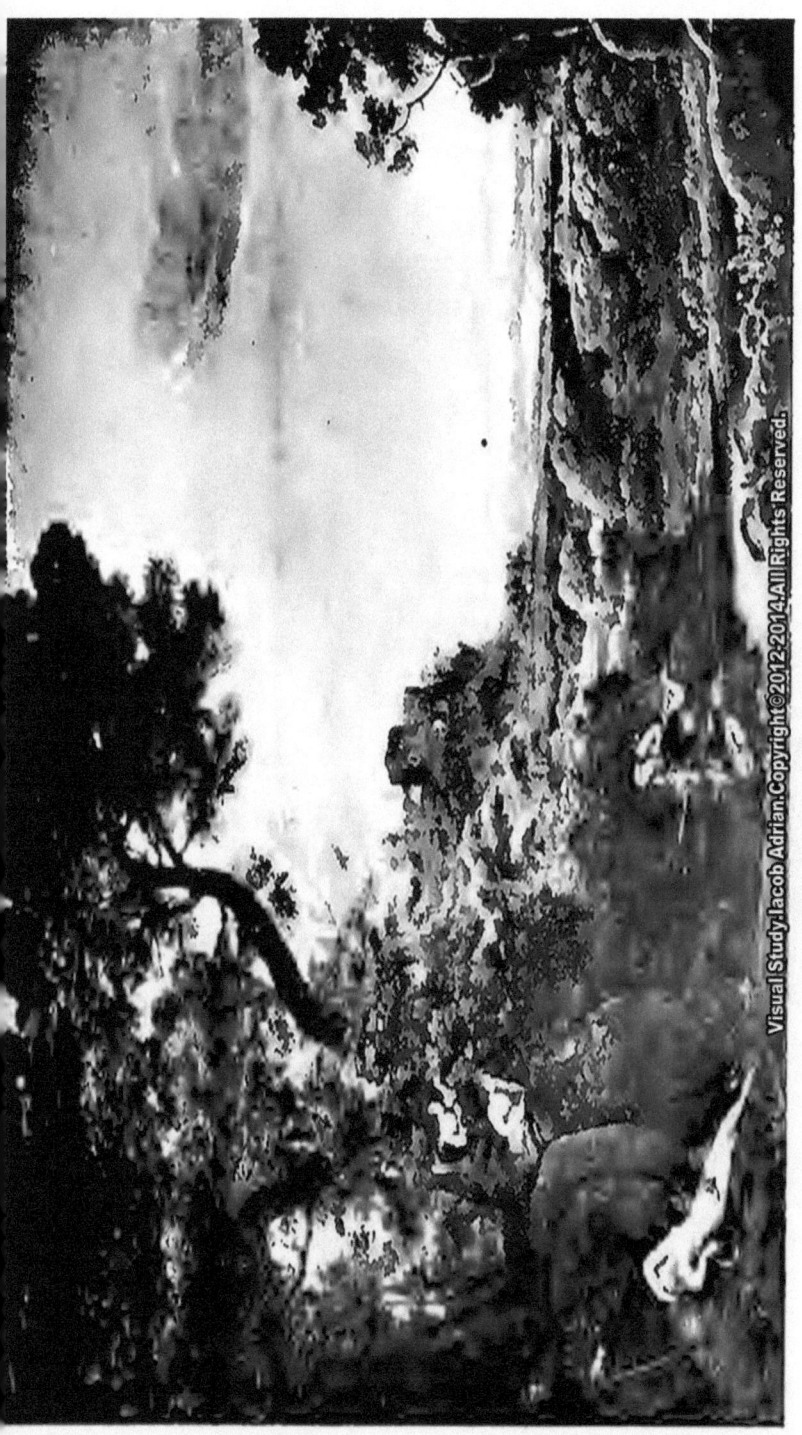

ECHO AND NARCISSUS ECHO UND NARZISS ÉCHO ET NARCISSE
[L.V. 77]
(*National Gallery, London*)
W. A. Mansell & Co., Photo.

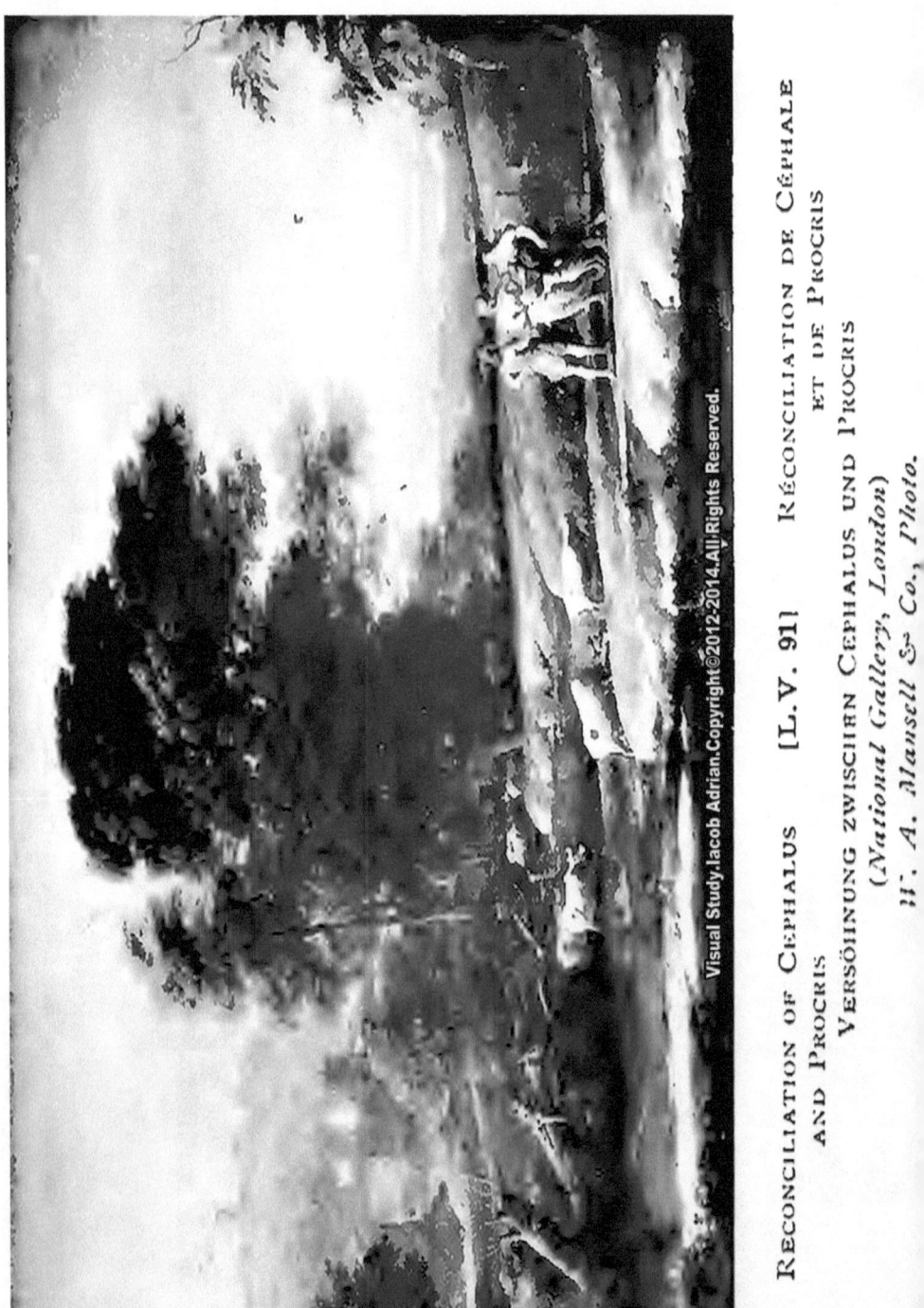

Reconciliation of Cephalus and Procris [L.V. 91] Réconciliation de Céphale et de Procris
Versöhnung zwischen Cephalus und Procris
(National Gallery, London)
W. A. Mansell & Co., Photo.

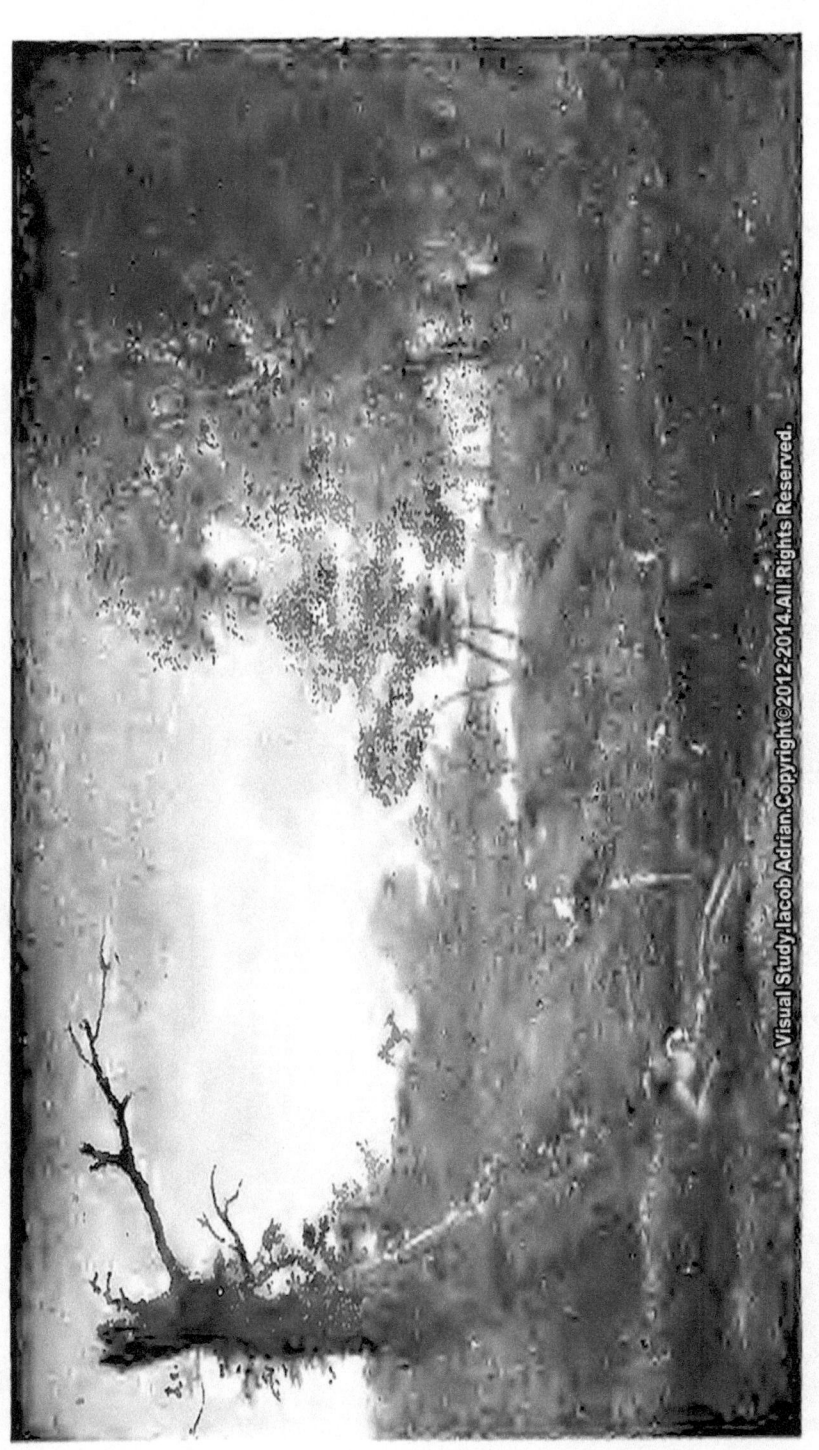

DEATH OF PROCRIS TOD DER PROCRIS MORT DE PROCRIS
[L.V. 100]
(*National Gallery, London*)
W. A. Mansell & Co., Photo.

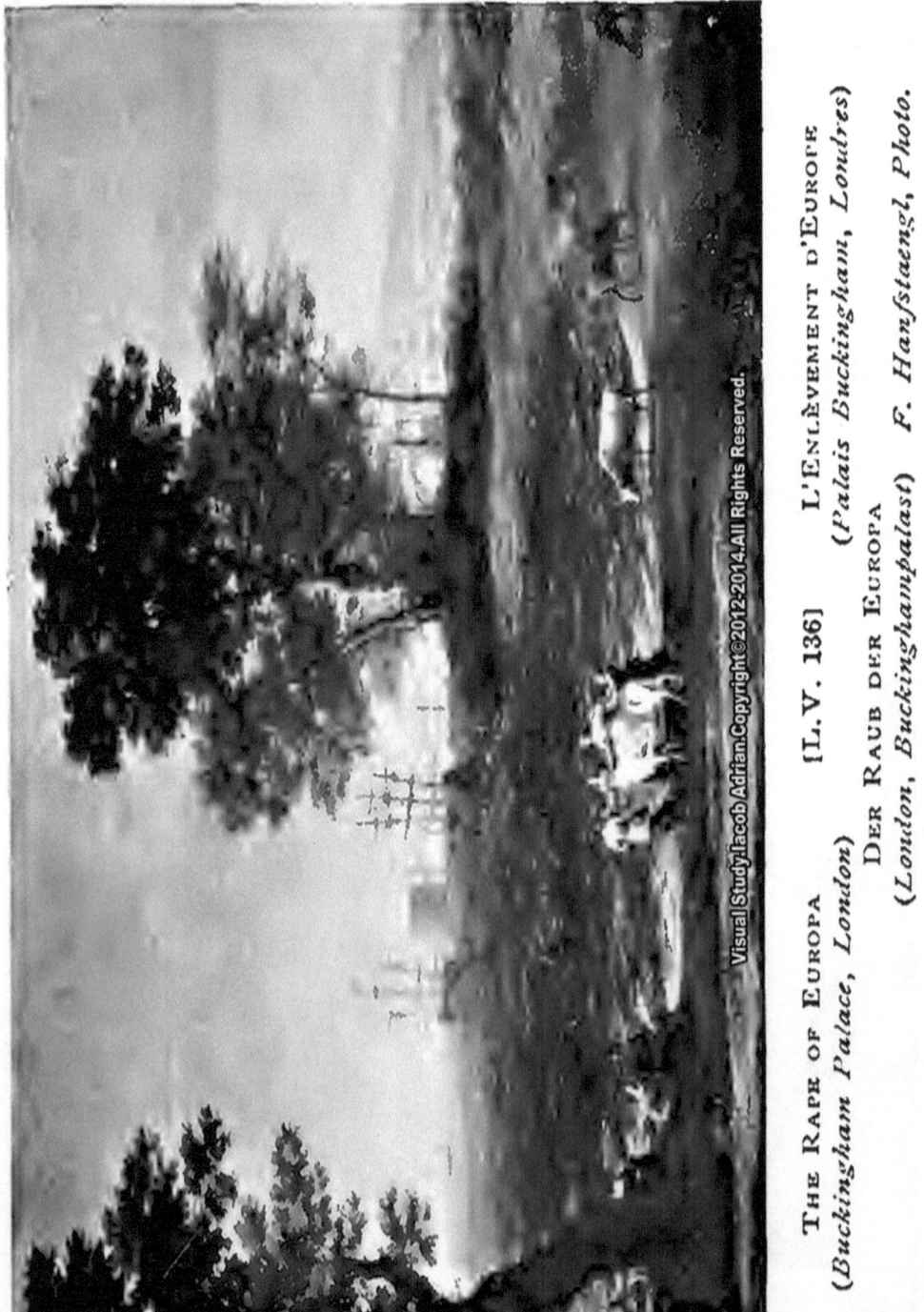

THE RAPE OF EUROPA [L.V. 136] L'ENLÈVEMENT D'EUROPE
(Buckingham Palace, London) (Palais Buckingham, Londres)
DER RAUB DER EUROPA
(London, Buckinghampalast) F. Hanfstaengl, Photo.

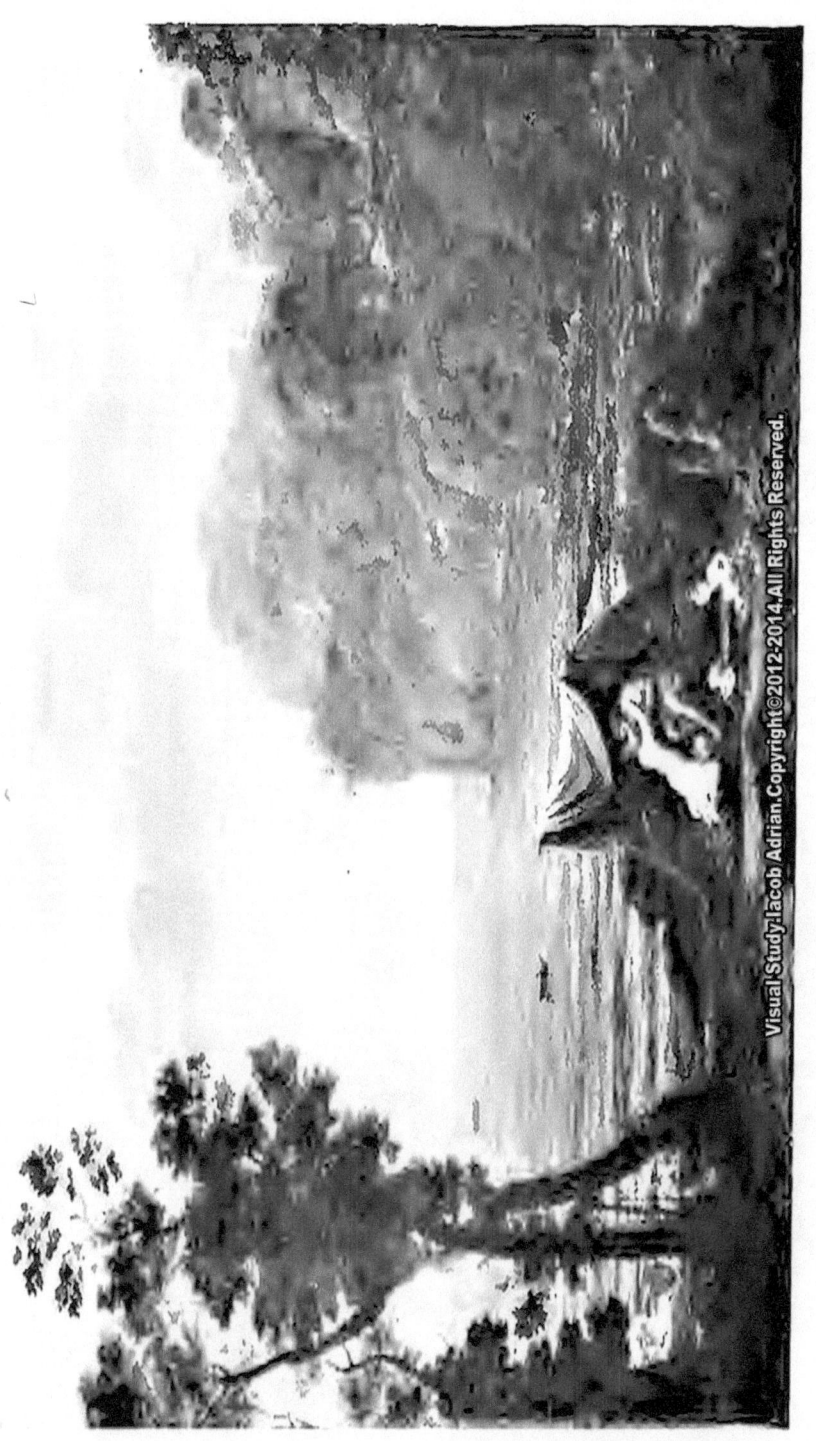

[L.V. 141]

ACIS AND GALATEA
(Royal Gallery, Dresden)

AKIS UND GALATEA
(Dresden, Kgl. Galerie)
F. Hanfstaengl, Photo.

ACIS ET GALATÉE
(Galerie royale, Dresde)

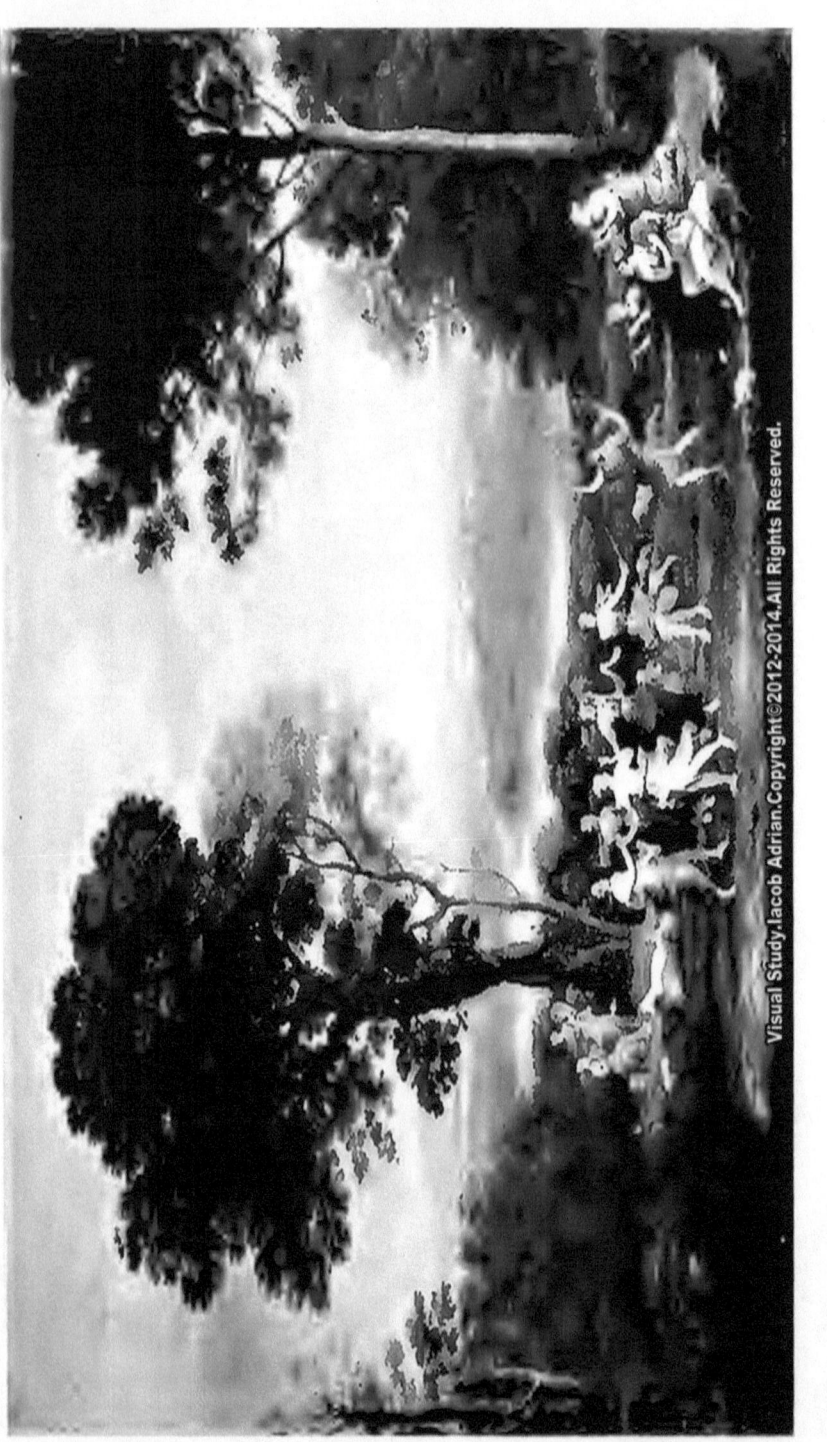

Metamorphosis of the Apuleian Shepherd [L.V. 142] Métamorphose du Berger d'Apulie
Verwandlung des Apulischen Schäfers
(Earl of Ellesmere, London) Walter L. Bourke, Photo.

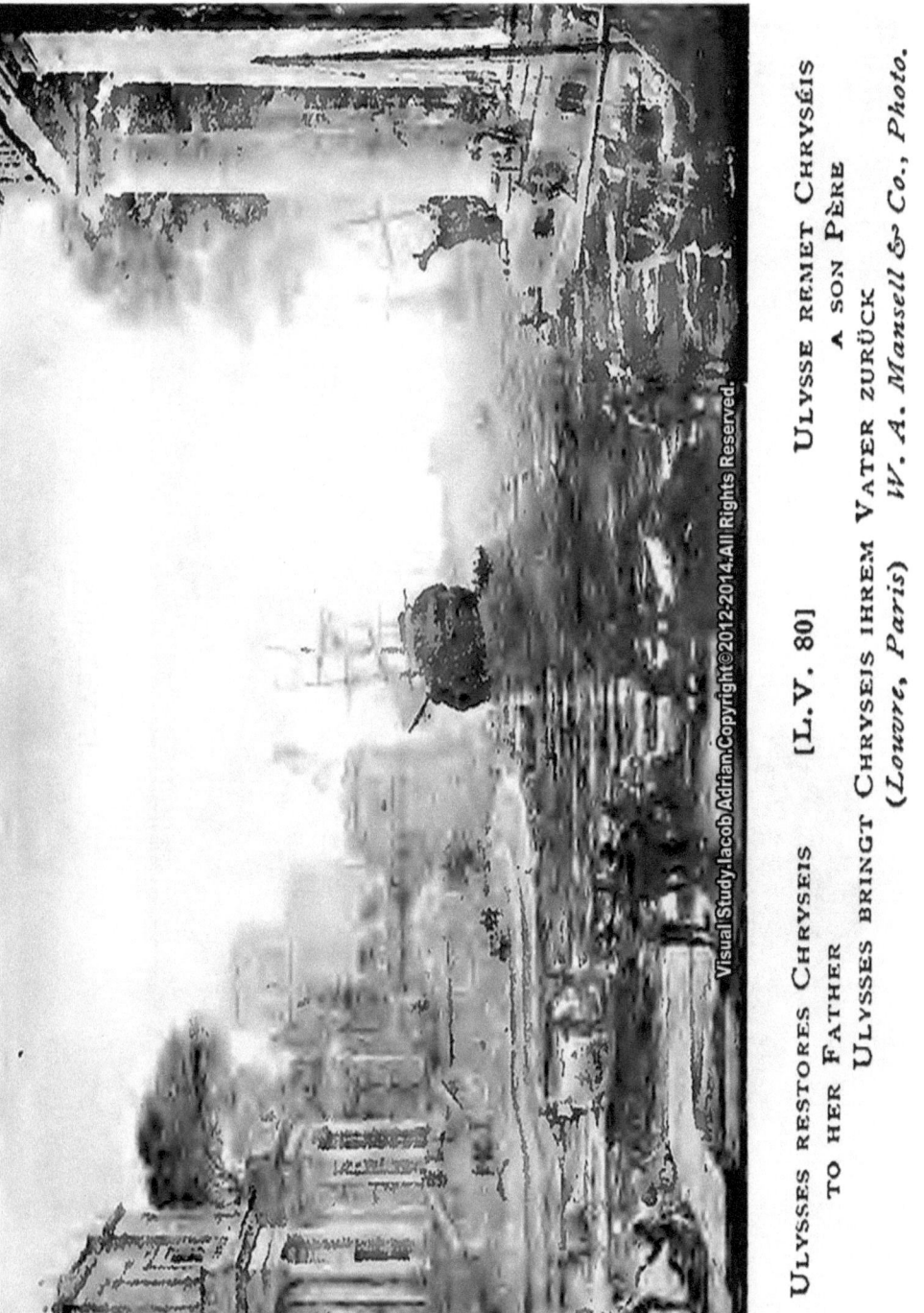

Ulysses restores Chryseis to her Father [L.V. 80] Ulysse remet Chryséis a son Père
Ulysses bringt Chryseis ihrem Vater zurück (Louvre, Paris) W. A. Mansell & Co., Photo.

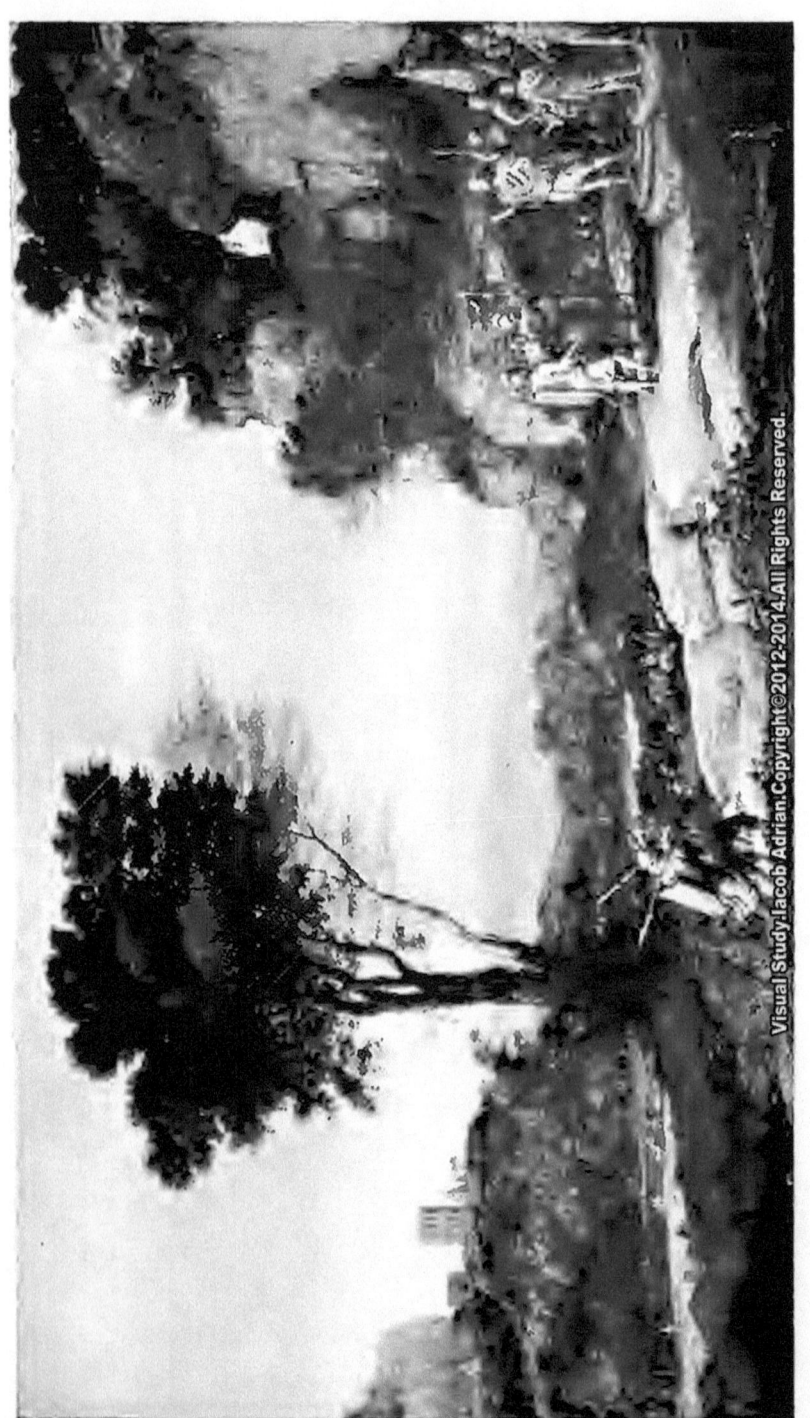

[L.V. 145]
SINON VOR PRIAMUS
(National Gallery, London)
W. A. Mansell & Co., Photo.

SINON BEFORE PRIAM SINON DEVANT PRIAM

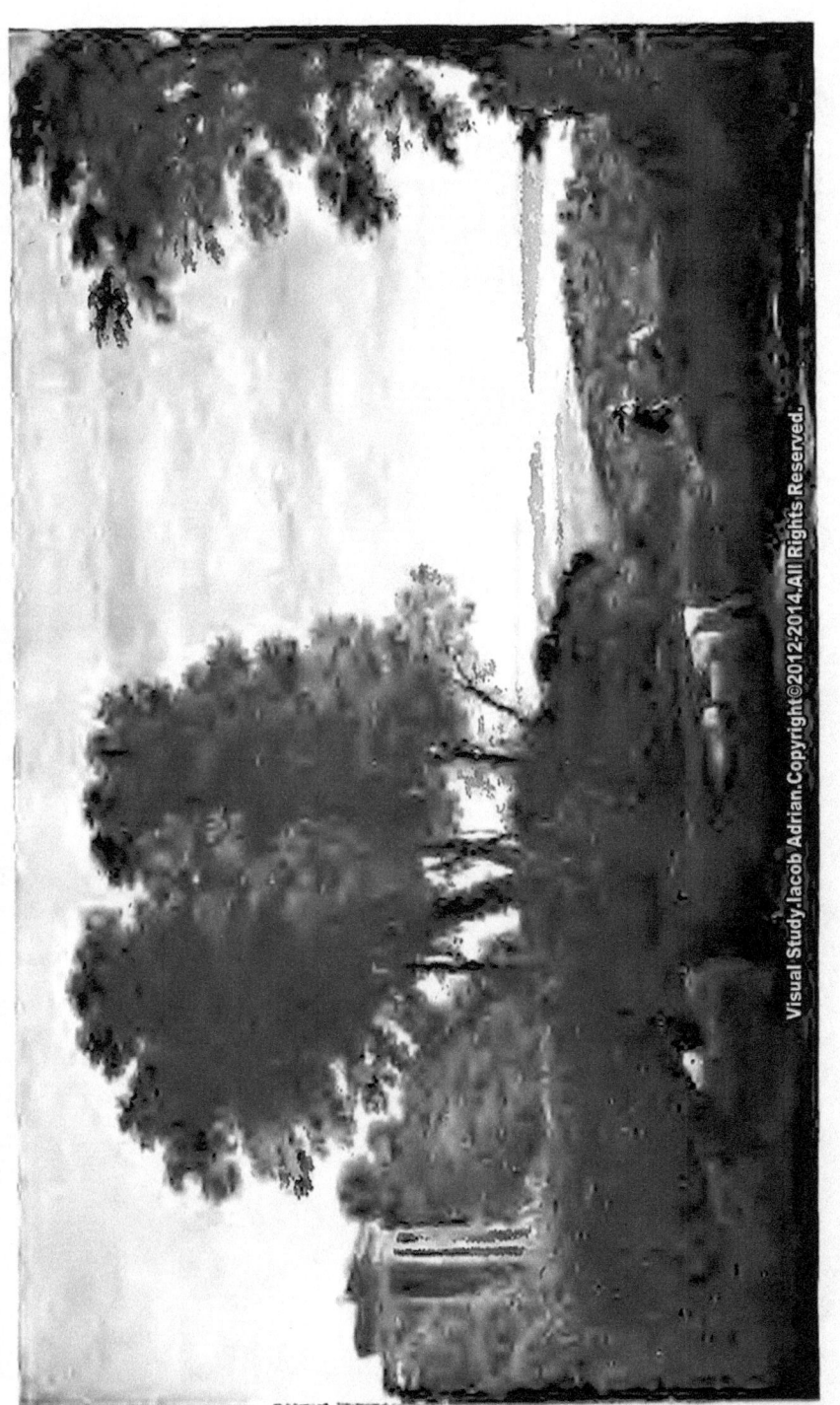

MERCURY AND BATTUS [L.V. 159] MERCURE ET BATTUS
MERKUR UND BATTUS
(Duke of Devonshire, Chatsworth)
F. Hanfstaengl, Photo.

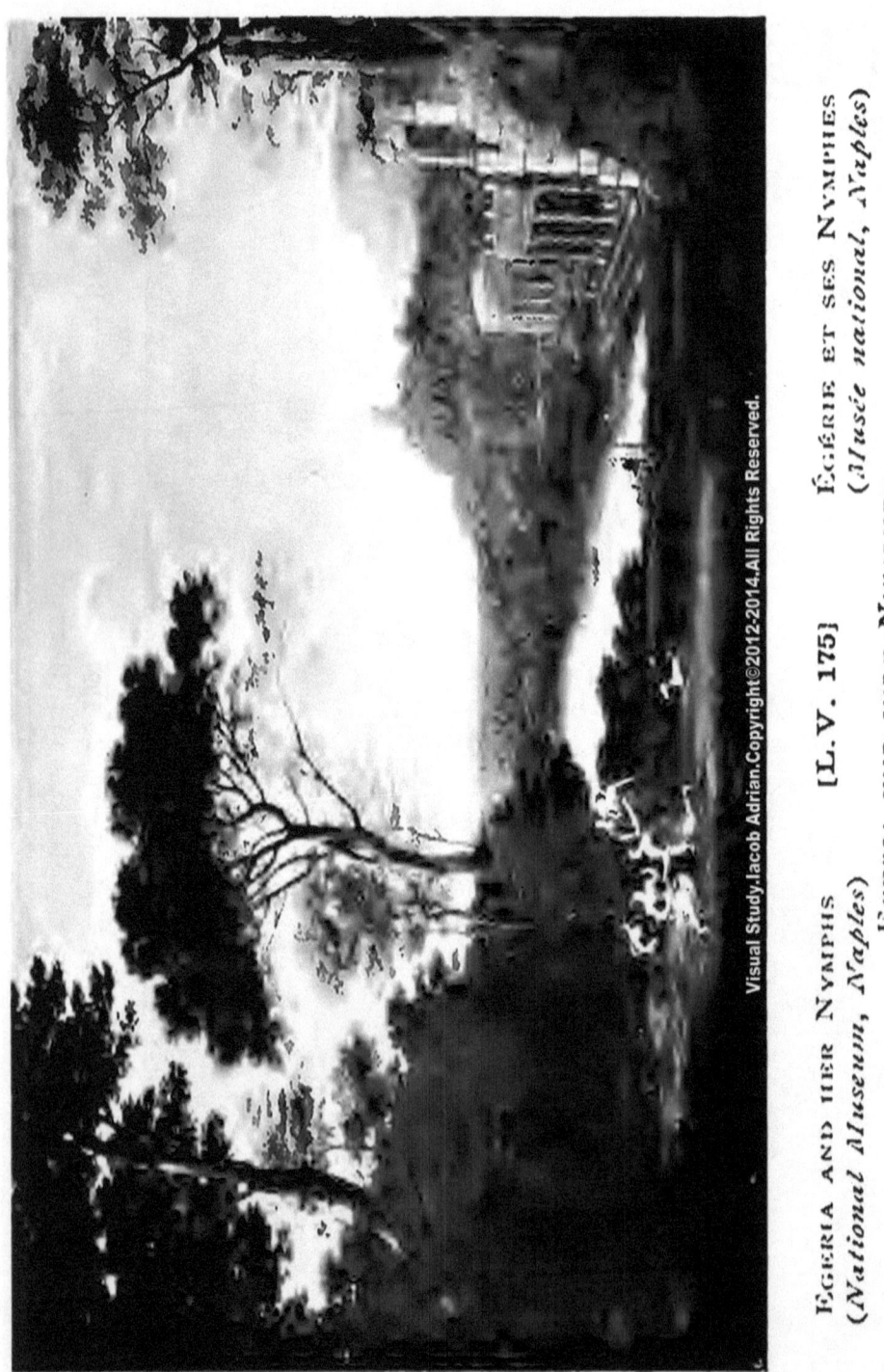

EGERIA AND HER NYMPHS [L.V. 175] ÉGÉRIE ET SES NYMPHES
(National Museum, Naples) (Musée national, Naples)
EGERIA UND IHRE NYMPHEN
(Neapel, Nationalmuseum) G. Brogi, Photo.

THE CAMPO VACCINO AT ROME [L.V. 10] LE CAMPO VACCINO A ROME
DER CAMPO VACCINO IN ROM
(*Louvre, Paris*) *W. A. Mansell & Co., Photo.*

THE FORD
(Gallery, Buda-Pesth)

[L.V. 107]
DIE FURT
(Budapest, Galerie)
F. Hanfstaengl, Photo.

LE GUÉ
(Galerie, Budapest)

THE FORD [L.V. 117] LE GUÉ
DIE FURT
(*Louvre, Paris*)
W. A. Mansell & Co., Photo.

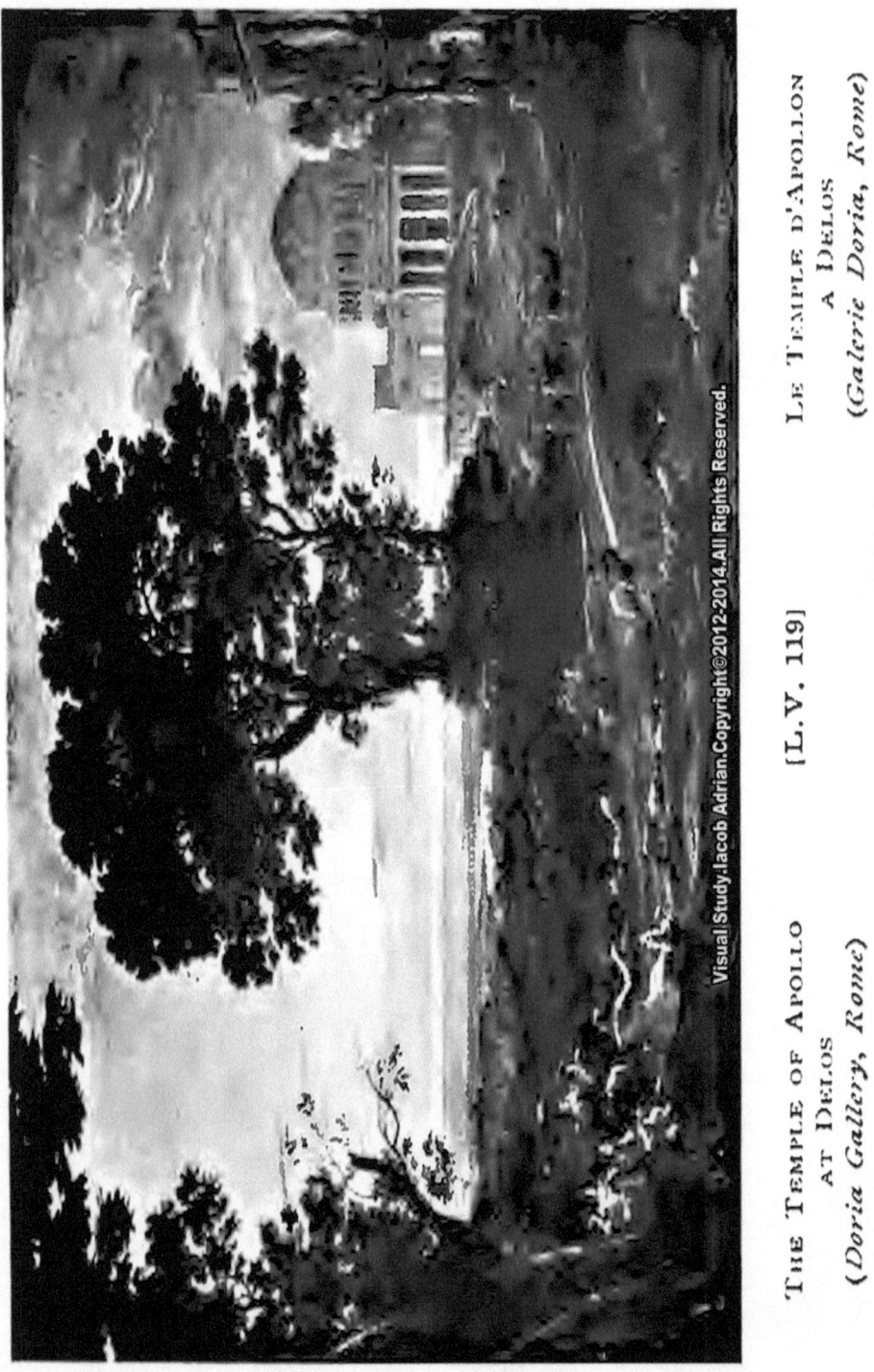

The Temple of Apollo
AT Delos
(Doria Gallery, Rome)

[L.V. 119]

Le Temple d'Apollon
a Delos
(Galerie Doria, Rome)

Apollotempel in Delos
(Rom, Galerie Doria)

D. Anderson, Photo.

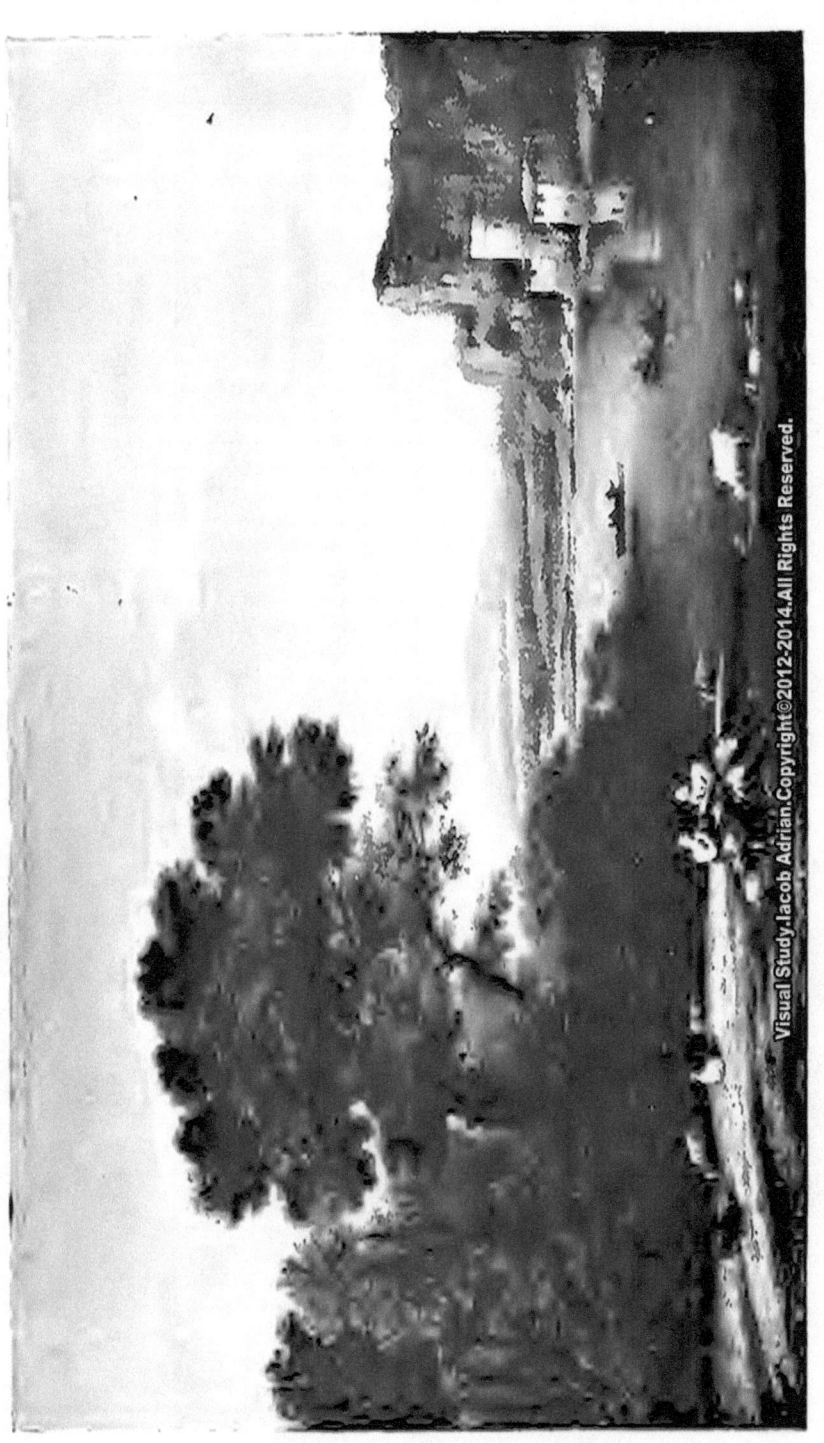

Mill on the Tiber [L.V. 123] Moulin sur le Tibre
Mühle am Tiber
(Earl of Northbrook, London)
F. Hanfstaengl, Photo.

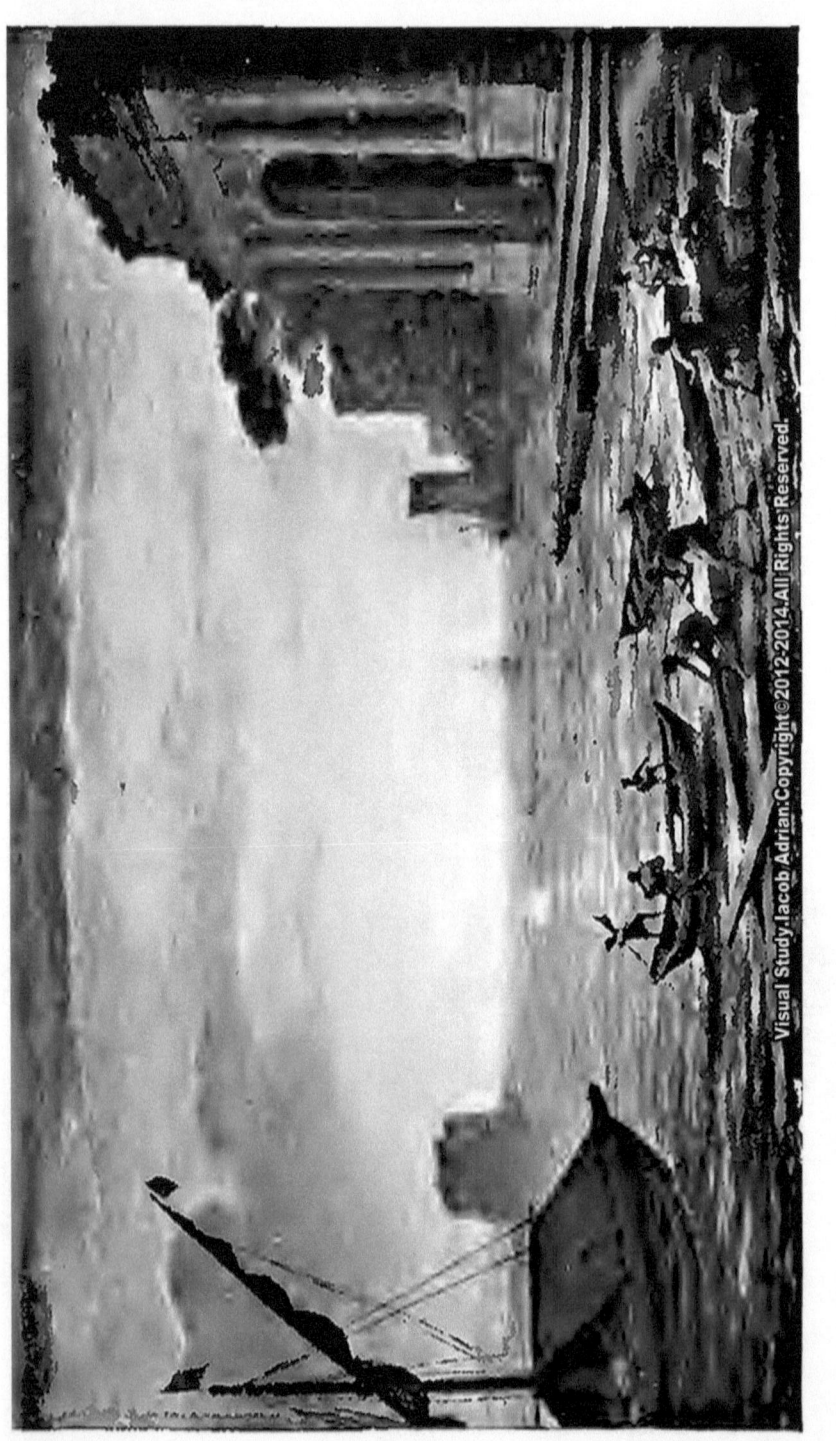

Seaport at Sunrise [L.V. 5] Port de Mer au Soleil levant
(Pinacotheca, Munich) (Pinacothèque, Munich)
Seehafen bei Sonnenaufgang F. Hanfstaengl, Photo.
(München, Pinakothek)

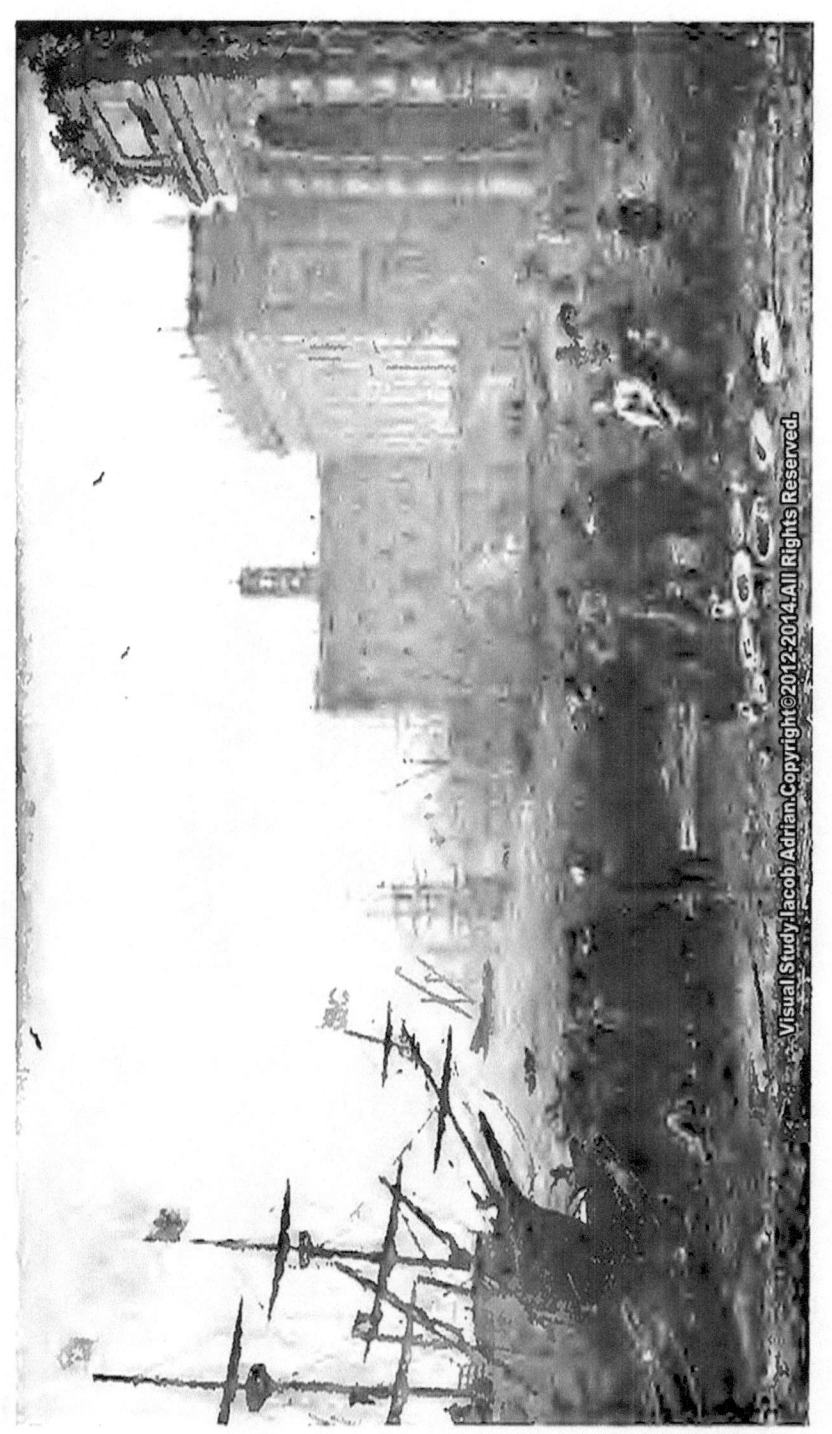

Seaport at Sunrise [L.V. 9] Port de Mer au Soleil levant
Seehafen bei Sonnenaufgang
(*Louvre, Paris*)
W. A. Mansell & Co., Photo.

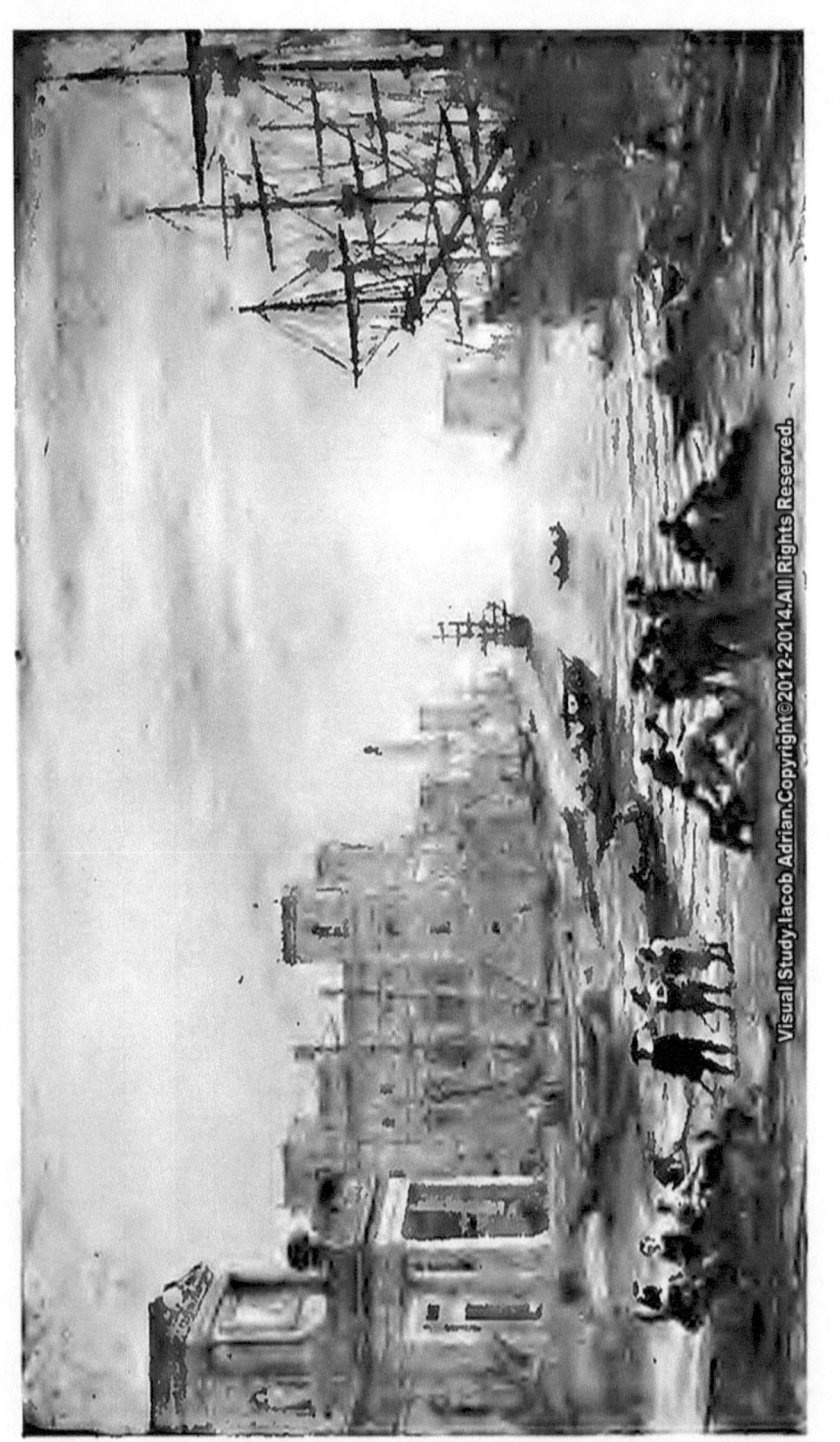

SEAPORT AT SUNSET [L.V. 14] PORT DE MER AU SOLEIL COUCHANT
SEEHAFEN BEI SONNENUNTERGANG
(*Louvre, Paris*)
W. A. Mansell & Co., Photo.

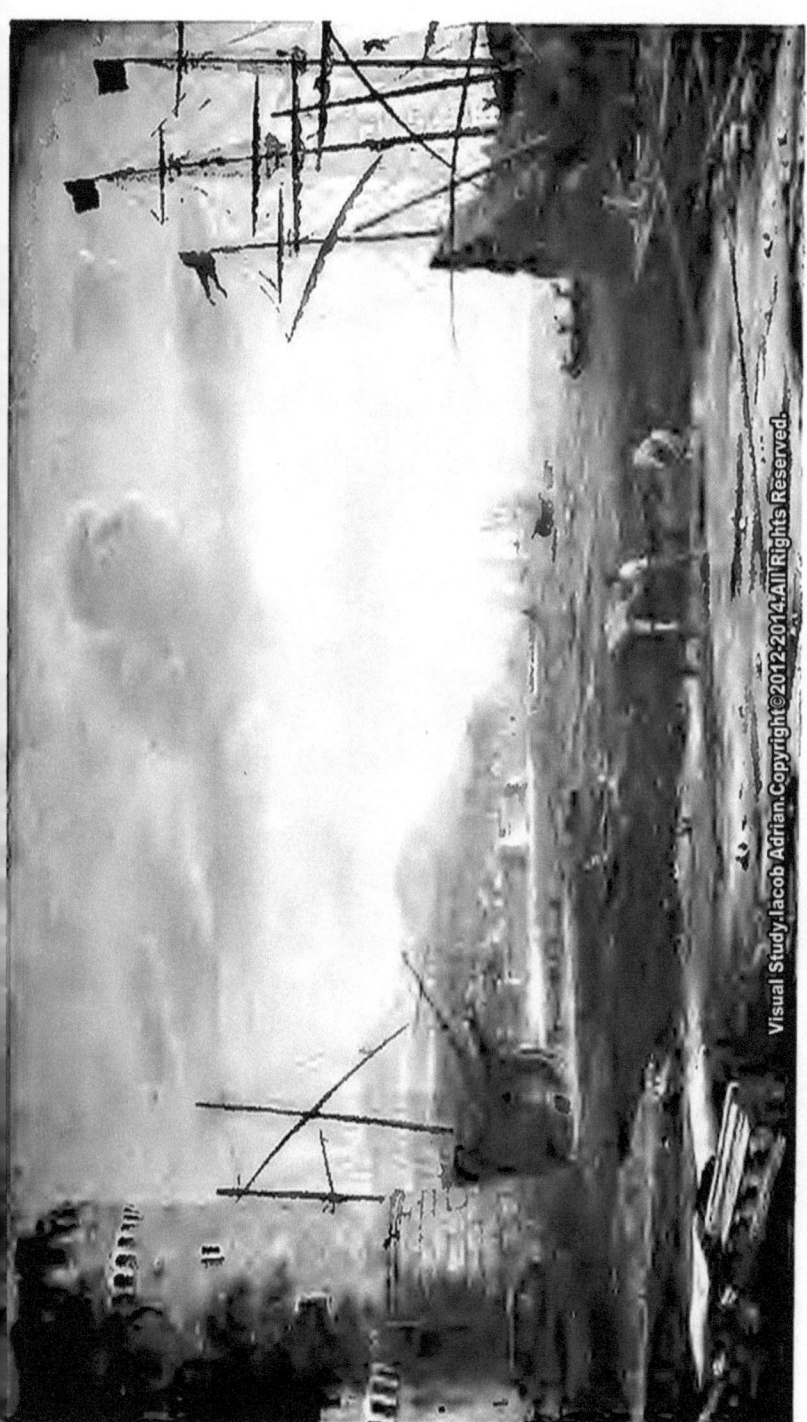

SEAPORT

[L.V. 17]
SEEHAFEN
(Musée Municipal, Grenoble)
Braun, Clément & Cie, Photo.

PORT DE MER

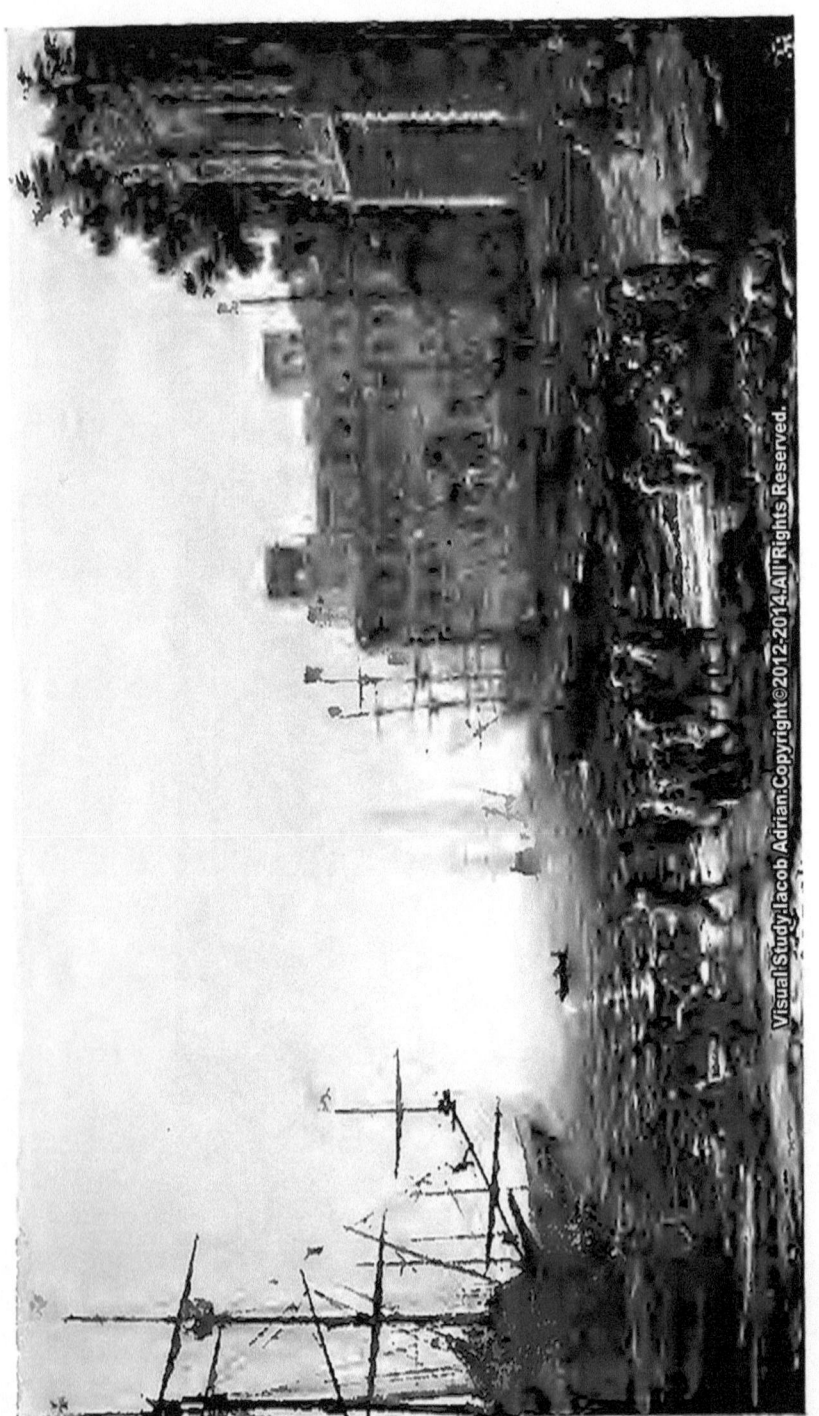

[L.V. 28]

SEAPORT
(Uffizi, Florence)

SEEHAFEN
(Florenz, Uffizien)
G. Brogi, Photo.

PORT DE MER
(Galerie des Offices, Florence)

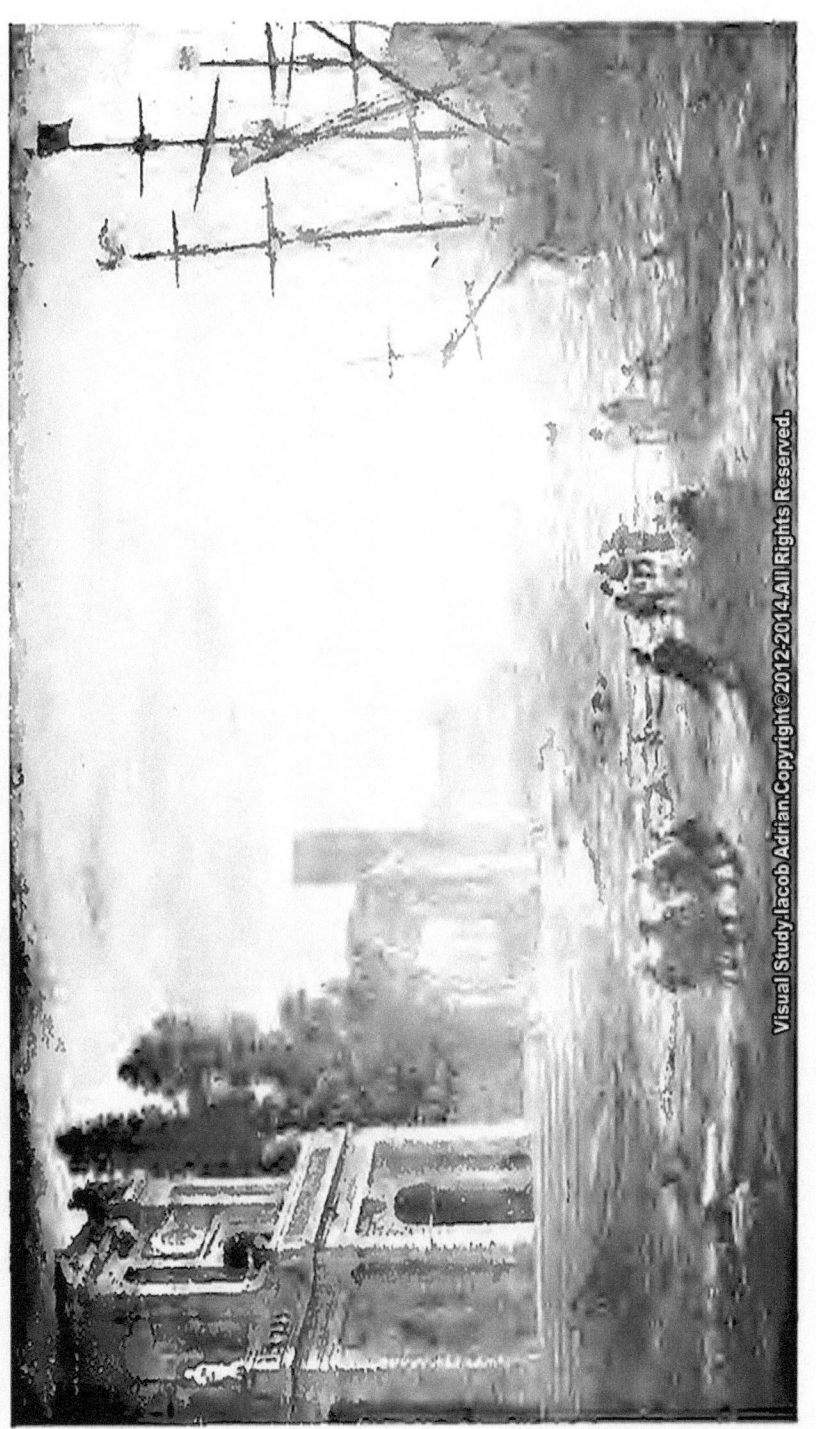

SEAPORT AT SUNSET [L.V. 43] PORT DE MER AU SOLEIL COUCHANT
SEEHAFEN BEI SONNENUNTERGANG
(*National Gallery, London*)
W. A. Mansell & Co., Photo.

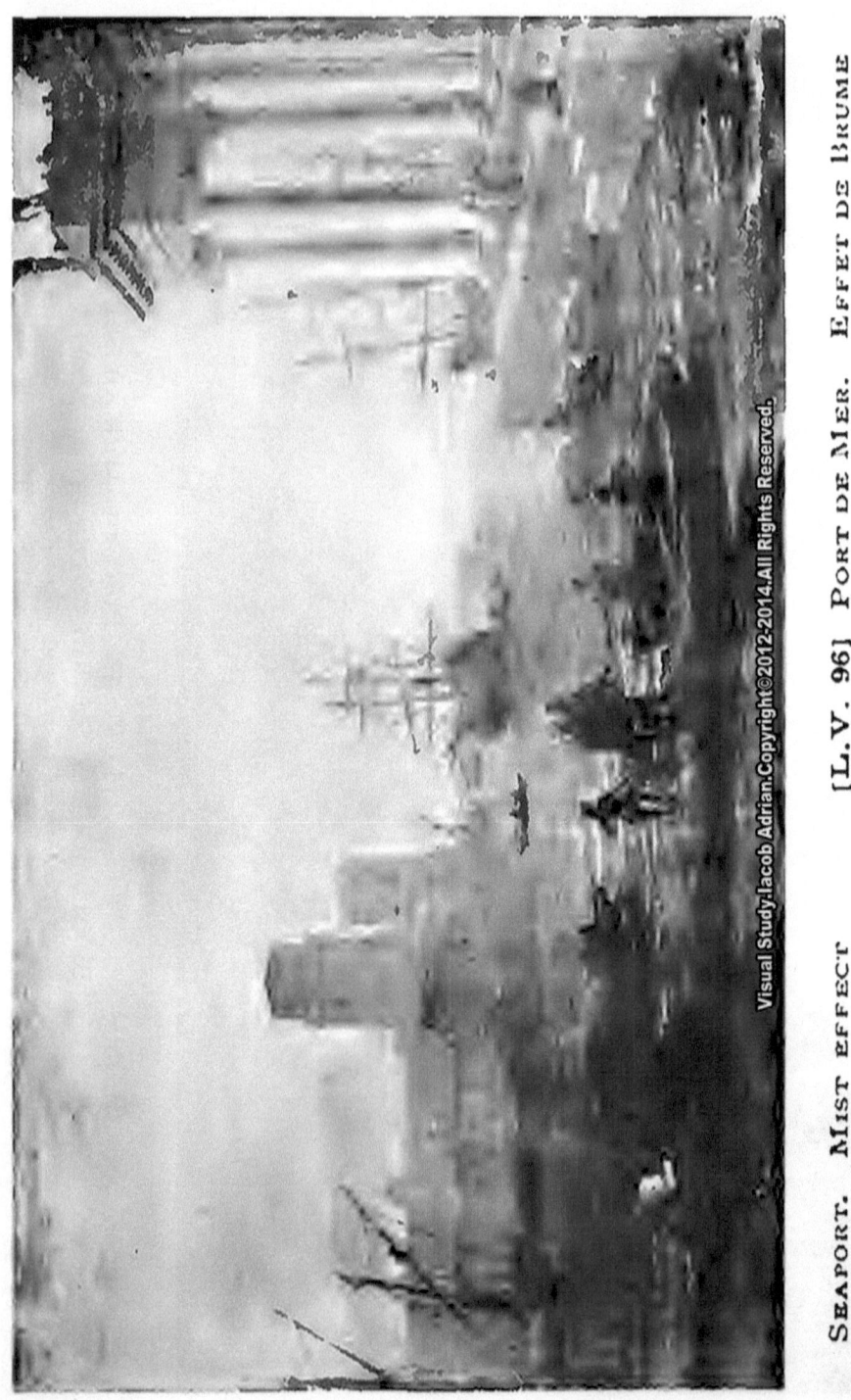

SEAPORT. MIST EFFECT [L.V. 96] PORT DE MER. EFFET DE BRUME
SEEHAFEN. NEBELSTIMMUNG
(*Louvre, Paris*)
W. A. Mansell & Co., Photo.

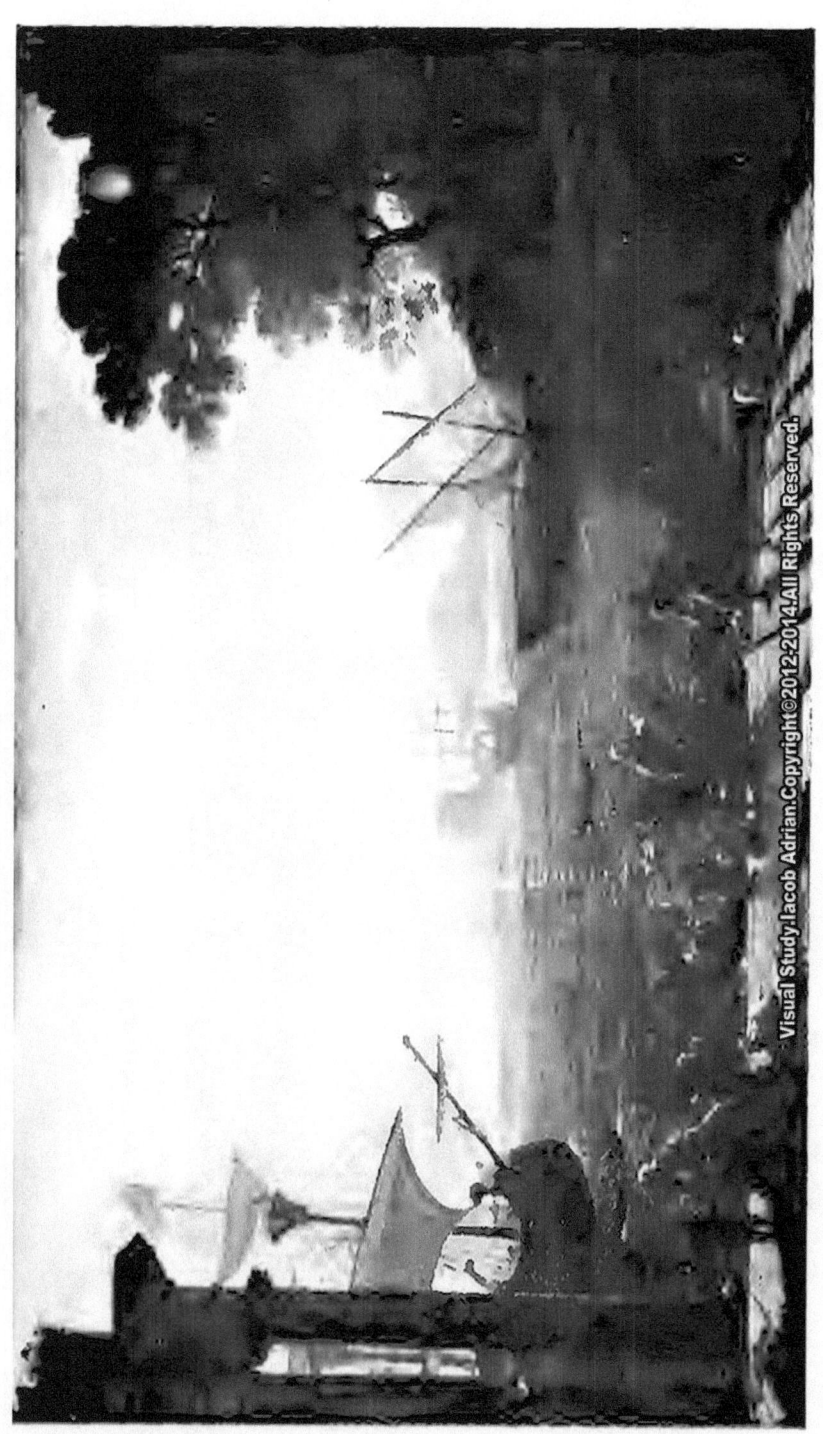

[L.V. 120]
SEEHAFEN
(Louvre, Paris)
W. A. Mansell & Co., Photo.

SEAPORT

PORT DE MER

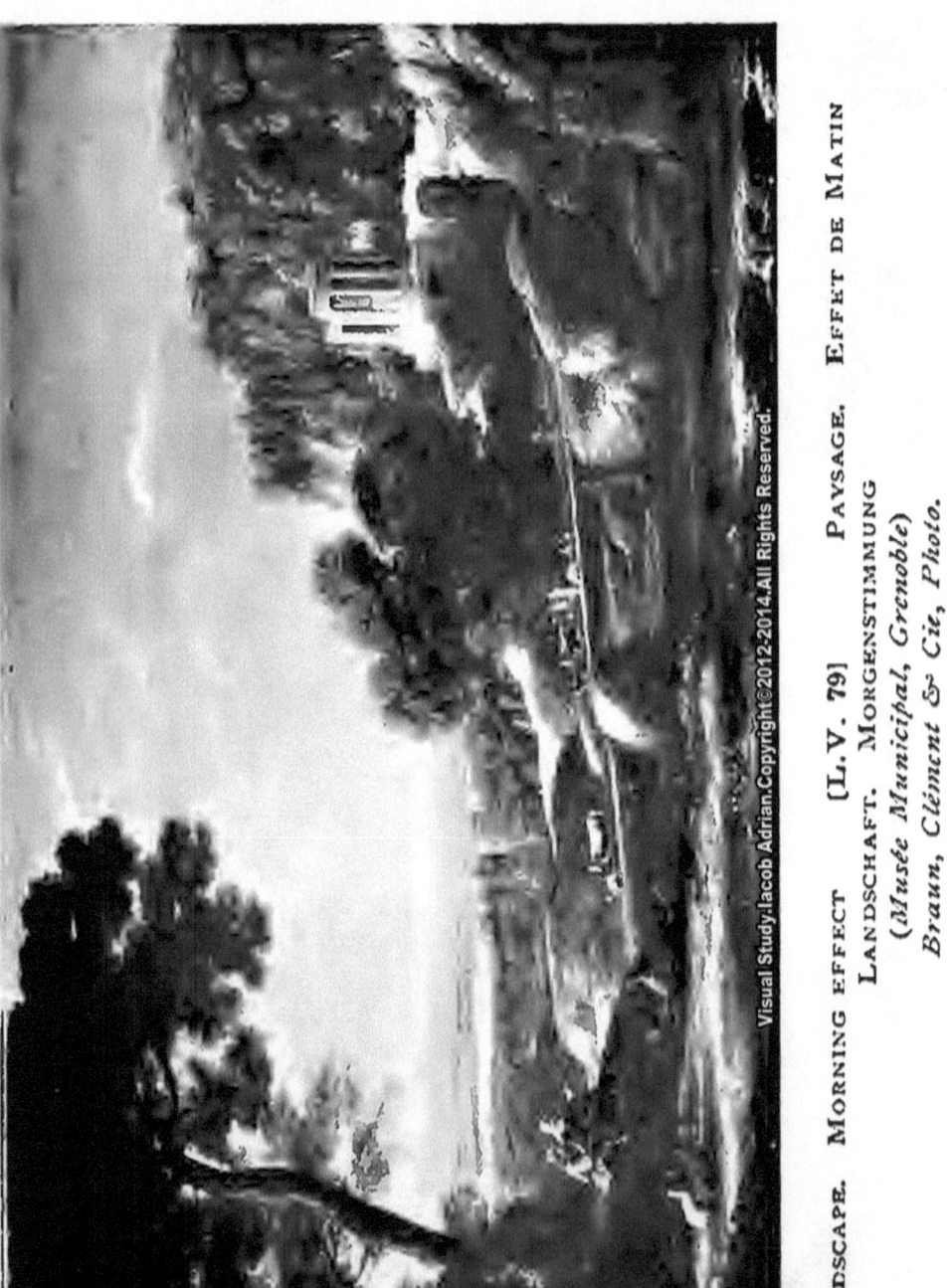

LANDSCAPE. MORNING EFFECT [L.V. 79] PAYSAGE. EFFET DE MATIN
LANDSCHAFT. MORGENSTIMMUNG
(Musée Municipal, Grenoble)
Braun, Clément & Cie, Photo.

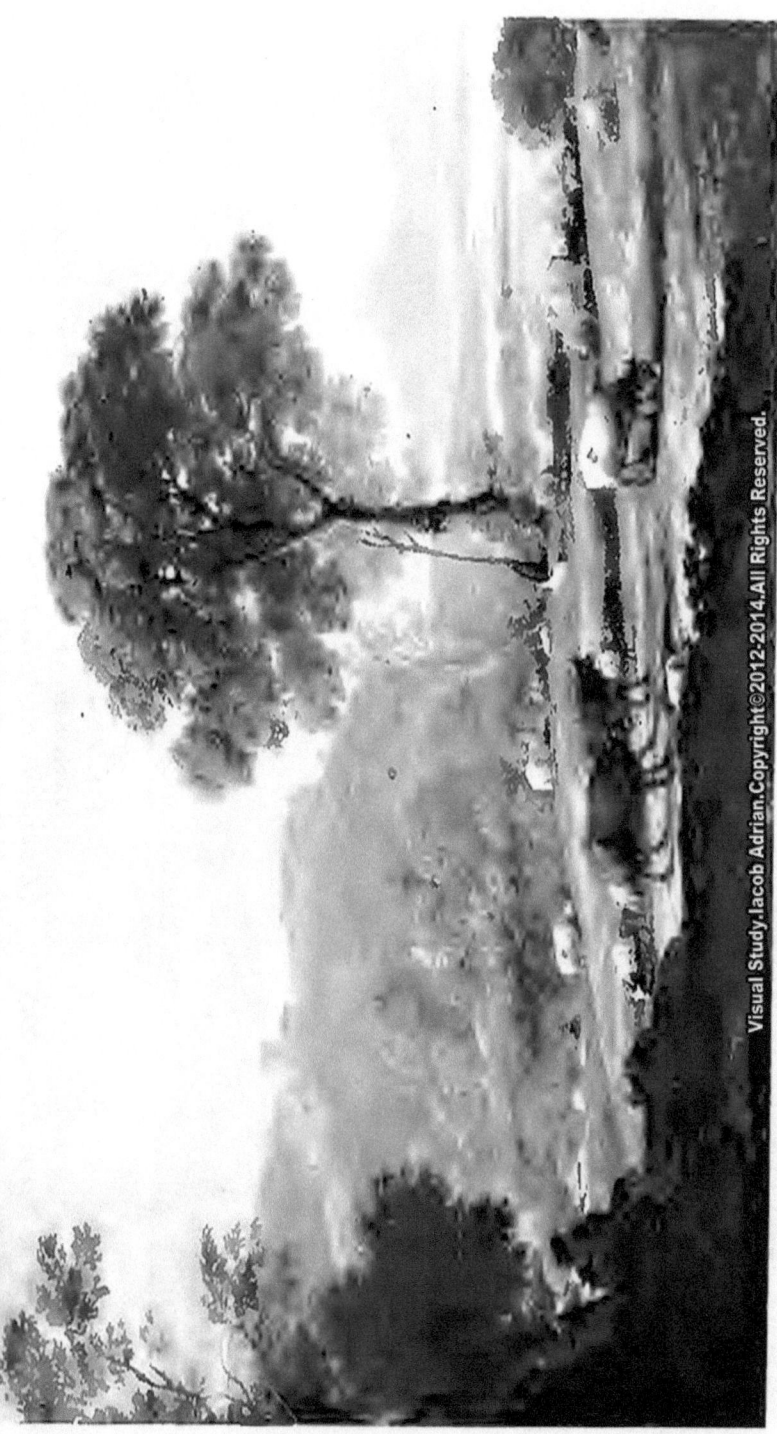

LANDSCAPE [L.V. 101]
LANDSCHAFT
(Earl of Ellesmere, London)
Walter L. Bourke, Photo.
PAYSAGE

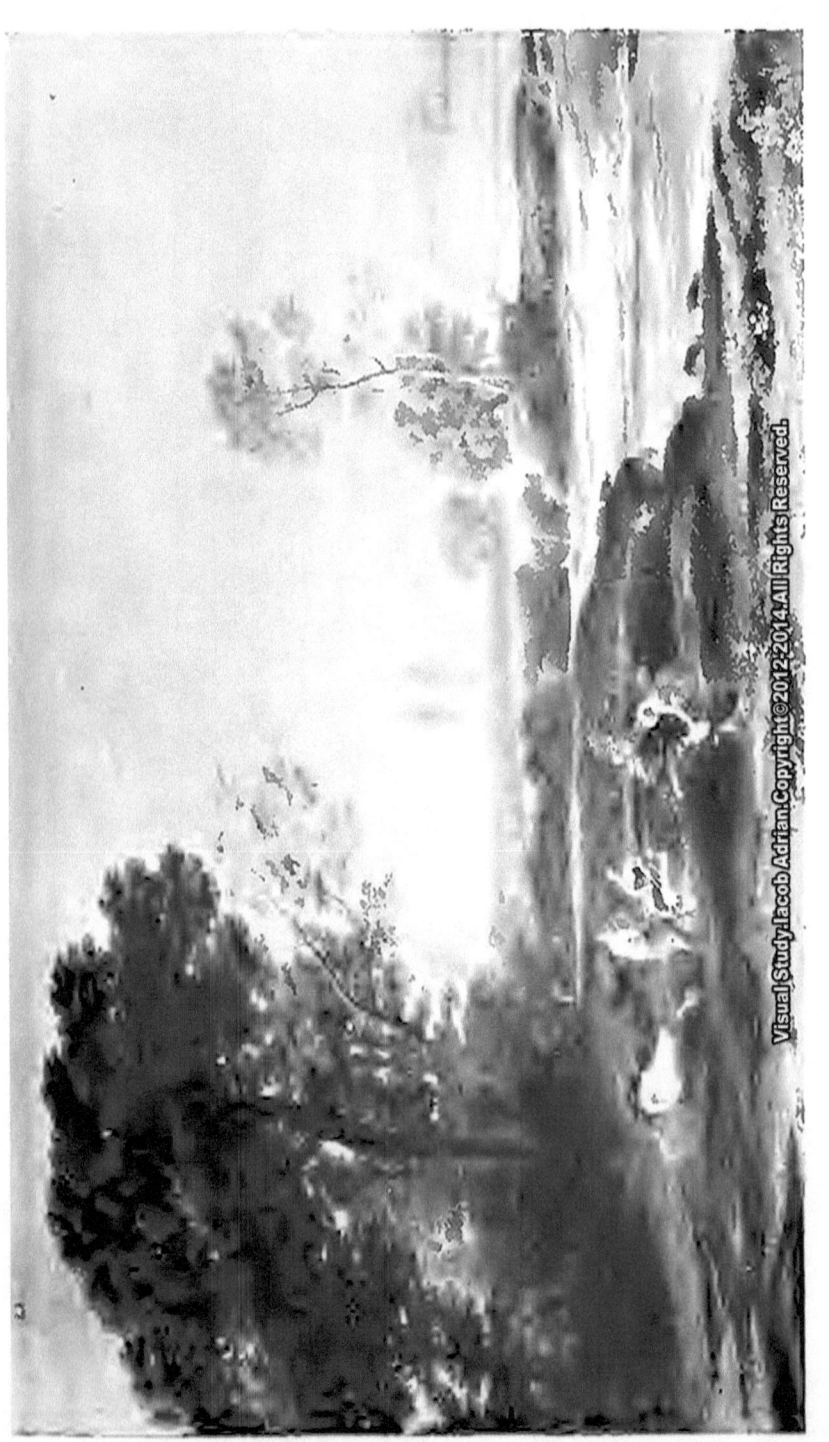

[L.V. 110]

LANDSCAPE
(Royal Gallery, Dresden)

LANDSCHAFT
(Dresden, Kgl. Galerie)
F. Hanfstaengl, Photo.

PAYSAGE
(Galerie royale, Dresde)

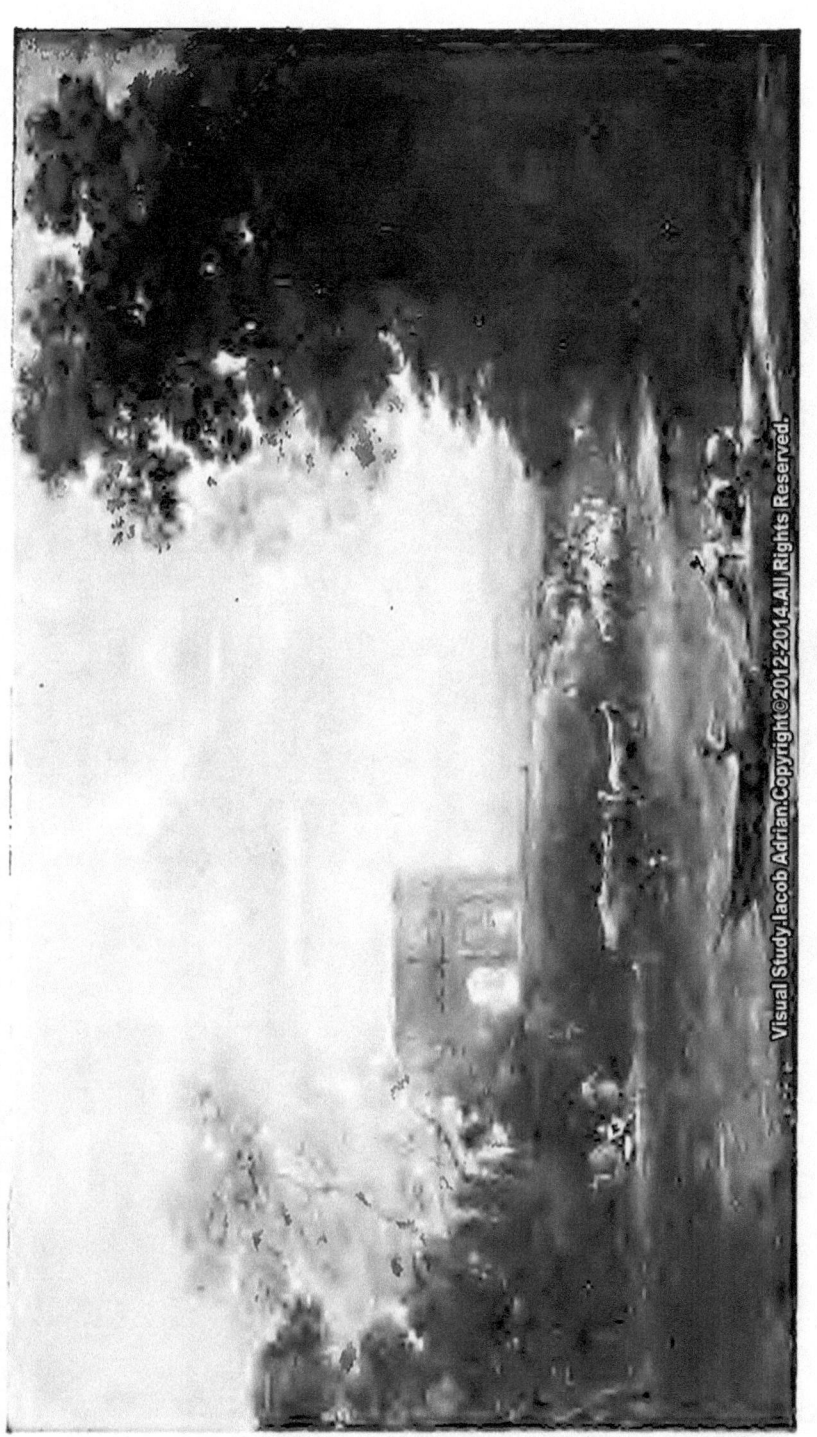

[L.V. 115]
LANDSCAPE: MORNING MORGENLANDSCHAFT PAYSAGE: MATIN
(*Duke of Westminster, London*)
Braun, Clément & Cie, Photo.

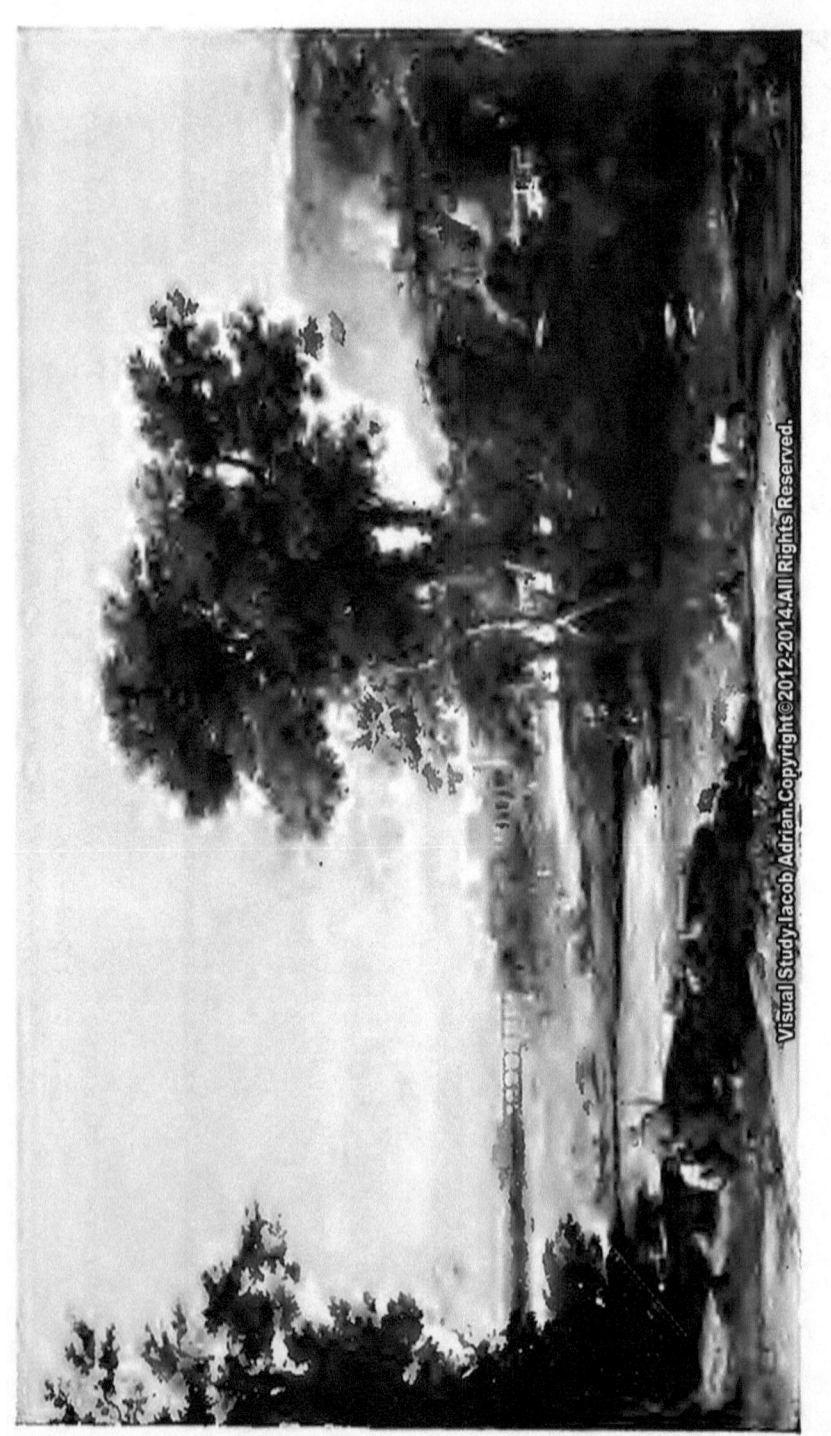

[L.V. 124]

LANDSCAPE: EVENING ABENDLANDSCHAFT PAYSAGE: SOIR
(*Duke of Westminster, London*)
Braun, Clément & Cie, Photo.

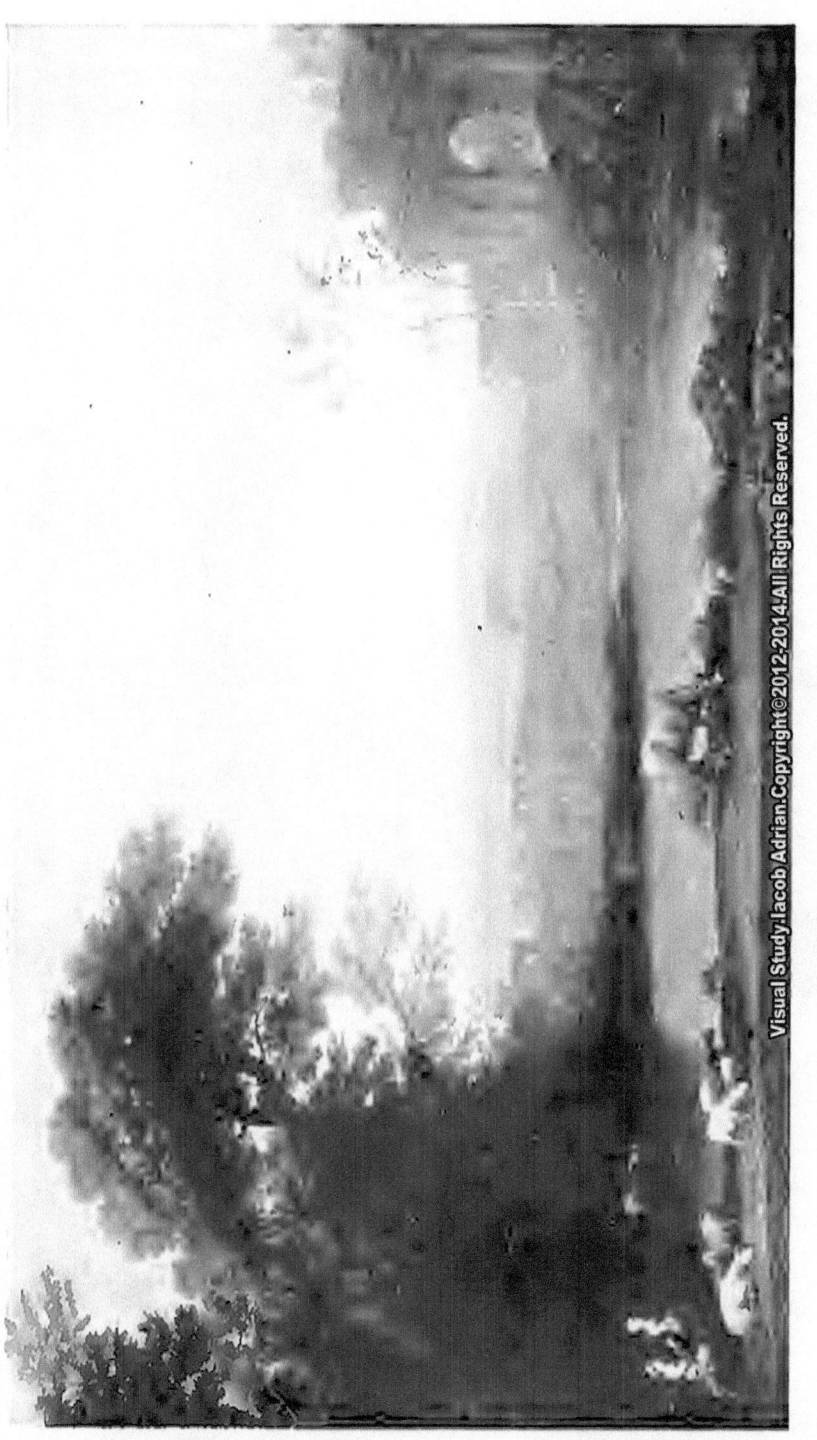

LANDSCAPE: DECLINE OF THE [L.V. 153] PAYSAGE: DÉCADENCE DE
ROMAN EMPIRE L'EMPIRE ROMAIN
LANDSCHAFT: VERFALL DES RÖMISCHEN REICHES
(*Duke of Westminster, London*) Braun, Clément & Cie, Photo.

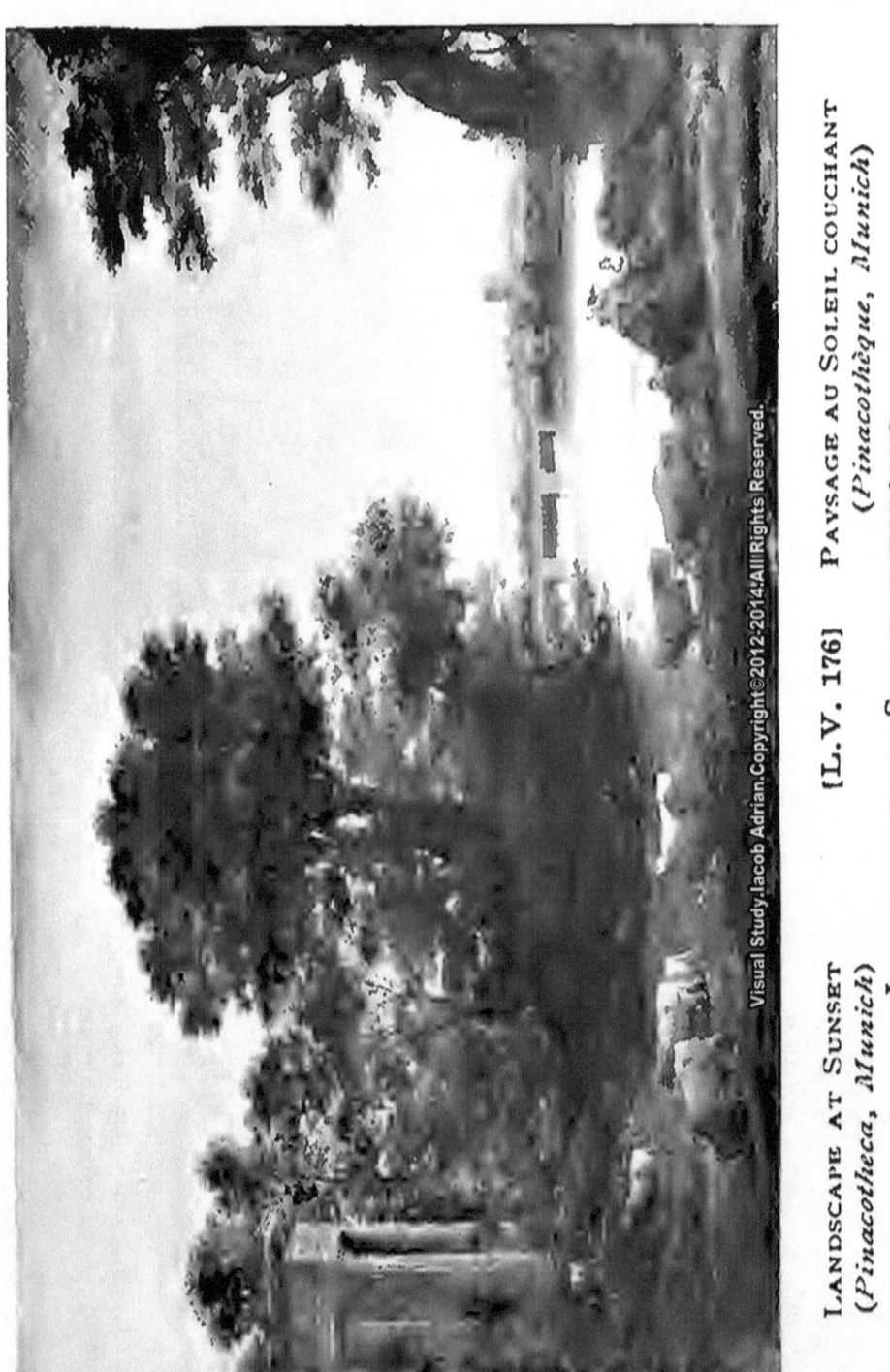

LANDSCAPE AT SUNSET [L.V. 176] PAYSAGE AU SOLEIL COUCHANT
(*Pinacotheca, Munich*) (*Pinacothèque, Munich*)
LANDSCHAFT BEI SONNENUNTERGANG
(*München, Pinakothek*) *F. Hanfstaengl, Photo.*

Classical Landscape Klassische Landschaft Paysage classique
(National Gallery, London)
W. A. Mansell & Co., Photo.

Bibliographic sources :

The masterpieces of Claude (1600-1682) : sixty reproductions of photographs from the original paintings, affording examples of the different characteristics of the artist's work (1911)

Author: Lorrain, Claude, 1600-1682

Publisher: London ; Glasgow : Gowans & Gray, Ltd.

This documentary study use,
combined in various proportions,
elements from the following categories,
forms and subsets :
- fair use
- documentary
- documentary photography
- feature
- journalism
- arts journalism
- visual journalism
- photojournalism
- celebrity photography
in order to :
- employ material as the object of cultural critique ,
- quote to illustrate an argument or point ,
- use material in historical sequence,
providing independent opinion,
using photos, press articles, advertisements,
opinions of fans etc. ...

Copyright©2012-2014 Iacob Adrian
All Rights Reserved.

www.ingramcontent.com/pod-product-compliance
Lightning Source LLC
Chambersburg PA
CBHW021021180526
45163CB00005B/2064